The Campus History Series

CENTENARY COLLEGE
NEW JERSEY

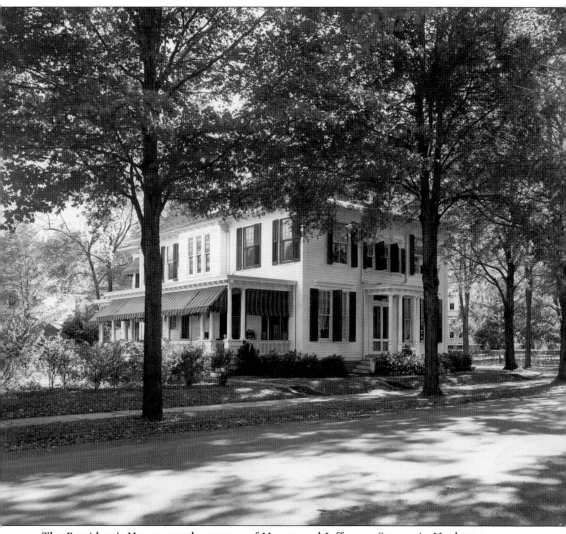

The President's House, on the corner of Moore and Jefferson Streets in Hackettstown, was originally built in Morristown. It was purchased by the Hoffman family in 1910, taken apart, numbered, and shipped by railroad to its present location. There was enough material left over to build the house next door on Moore Street for Mrs. Hoffman's mother. The family lived in the home until it was sold to Centenary College in 1946. The photograph was taken in October 1945, a few months before the building was purchased by the college. (Centenary College Archives.)

ON THE COVER: Taken in 1946, this image shows students of Centenary Junior College taking an exam in the biology laboratory in Trevorrow Hall. Dedicated in 1941, the building housed science, art, and home economics programs. It was named for Dr. Robert Johns Trevorrow, president of Centenary Collegiate Institute from 1917 to 1940 and president of Centenary Junior College from 1929 to 1943. (Centenary College Archives.)

CONTENTS

ACKNOWLEDGMENTS

This book would not have been possible without the foresight of the faculty, staff, and administration of Centenary College. From our earliest years, they established a tradition of preserving images, memories, and stories of campus life. Not only is our collection a treasure of the college's fascinating past, it stands as a valuable resource of the history of the town of Hackettstown and northwestern New Jersey as well.

I wish to thank Nancy Madasci, retired director of the Centenary library, and Timothy Domick, director. College archivist Colleen Bain and library assistant Wendi Blewett were of immense help in locating important (and misplaced) photographs, and Prof. Gary Caal provided expert assistance on digital imaging. I am grateful for the unwavering support of Pres. Barbara-Jayne Lewthwaite; Dr. James Patterson, provost and chief academic officer (and a fellow historian); and chief financial officer Roger Anderson. Their desire to have me bring the history of our college back to life truly made this book a reality.

I must also pay tribute to Dr. Ernest Rockwell Dalton, faculty member and administrator at Centenary from 1947 to 1980. His dream was to write a history of the college to be published after his retirement. Ernie died suddenly in 1984, and his unfinished manuscript was stored in several boxes in the archives until I discovered the incredible wealth of information he had collected. I know Dr. Dalton would have been pleased that I drew heavily upon his writings and research for this book.

I also thank the staff at Arcadia Publishing, who immediately saw the potential for a book on Centenary's history, and my editor, Erin Rocha, who patiently guided me through the technical aspects of document scanning and layout.

And finally, to my wife, Andra Lynne (Harris) Frey, Centenary class of 1979, whom I met so many years ago at Centenary and has been my unwavering source of love and encouragement.

Unless otherwise noted, all images appear courtesy of Centenary College.

The Campus History Series

CENTENARY COLLEGE

NEW JERSEY

Raymond Frey

ARCADIA
PUBLISHING

Published by Arcadia Publishing
Charleston, South Carolina

Printed in the United States of America

Library of Congress Catalog Card Number: 2012930694

For all general information, please contact Arcadia Publishing:
Telephone 843-853-2070
Fax 843-853-0044
E-mail sales@arcadiapublishing.com
For customer service and orders:
Toll-Free 1-888-313-2665

Visit us on the Internet at www.arcadiapublishing.com

To the students of Centenary College—
past, present, and future

INTRODUCTION

On a beautiful fall day in October 1865, the Reverend Crook S. Vancleve, presiding elder of the Morristown district of the Methodist Church, invited the Reverend George H. Whitney to his home on Washington Street in Hackettstown. After dinner, they walked about a third of a mile outside of town to a small rise in a recently harvested cornfield. Standing in the stubble of the cut cornstalks, they admired the magnificent view of the Musconetcong River Valley and the surrounding mountains.

Whitney exclaimed that it was "one of the most beautiful views I had anywhere seen." It was then that Reverend Vancleve revealed his plan. "I brought you here," he told Dr. Whitney, "because when the Conference shall build our great new Seminary, this is the spot where it ought to be built, and you are to be its first president."

In March 1866, the General Conference of the Methodist Church passed a resolution stating that "the educational wants of our people in the northern part of our State remain unmet . . . [and] we recommend to our people the erection of an academic institution that shall be an honor to the church and a blessing to future generations."

One year later, a charter was drafted by the Newark Annual Conference "to found an institution of learning in this State, whose object shall be for the promotion of learning." As 1867 also marked the centennial of Methodism in America, they chose the name Centenary.

The cornerstone was laid on September 9, 1869, and the first students were enrolled five years later. At its first commencement, Centenary became the first college in New Jersey to grant a degree to a woman.

A disastrous fire in 1899 destroyed the main building, but the trustees were determined to rebuild. By September 1901, with the help of the Newark Conference and the generosity of the residents of Hackettstown, the new building was finished and the students returned.

The women's college continued for 23 years; the coeducational preparatory program was offered until 1910. From 1910 to 1929, Centenary operated as a select preparatory school for girls. In 1929, the desire to offer a full college program led to the opening of Centenary Junior College for Women in addition to the collegiate institute. The rapid growth of the college programs led to the closing of the preparatory program, and the name Centenary Collegiate Institute was changed to Centenary Junior College in 1940.

Dr. Edward W. Seay, who was inaugurated in 1948, embarked one year later on an ambitious building program that included new dormitories, a student union, natatorium, classrooms, and library. The curriculum underwent major changes as well. In 1959, Centenary expanded its course for medical technologists into a four-year degree program, leading to a bachelor

of science. All other programs would continue to offer courses leading to the degree of associate in arts or associate in science. In 1956, the college's name was changed again, to Centenary College for Women.

In 1976, Centenary became a four-year institution for women, granting both associate and baccalaureate degrees. Also in that year, the Continuing Studies Department was created to allow men the opportunity to pursue degrees at Centenary in the evening. In 1988, breaking a tradition going back to 1910, Centenary again allowed men to attend all academic programs. One year later, they were offered dormitory space on campus.

In 1978, Centenary purchased a 65-acre horse farm in nearby Washington Township for its growing equestrian program. A new indoor riding facility was added in 2001, and the "back barn" and caretaker's house were completely renovated by volunteers in 2011. Students come from all over the country to ride for Centenary's outstanding equestrian team.

Between 1996 and 2006, five new campus buildings were added: the Harris and Betts Smith Learning Center, the Robert E. and Virginia N. Littell Technology Center, the renovated and expanded Reeves gymnasium, and two dormitories, Bennett-Smith and Founders Halls. During this time, Centenary also became the first New Jersey college campus with complete wireless access. Every incoming full-time student was provided with a laptop for their personal use.

In 2006, Centenary undertook the largest building project in its history. Supported by a generous gift from Carol Burgess Lackland (class of 1954) and her husband, Centenary trustee David Lackland, plans were drawn up for a state-of-the-art theater and performing arts center. Opened in 2010, it has made Centenary the center of a growing arts scene in northwestern New Jersey.

In 1992, Centenary created an Office of International Programs to recruit international students to the campus. Since that time, students from all over the world have come to study at Centenary, and our American students receive opportunities to study abroad. The diversity of our student body has changed dramatically as a result.

In 1999, Centenary College took a bold step into the adult education market with the inauguration of its Centenary Adult and Professional Studies program—popularly known as "CAPS." It gave students who could not attend a more traditional program, because of work and family obligations, the opportunity to earn a college degree. Now known as the School of Professional Studies, it offers even more flexibility through a large number of online courses and degree programs.

Since the school's earliest days, the goal of a Centenary education has been to provide a solid liberal arts foundation on which to prepare for a satisfying career. This is accomplished through the completion of a core of courses combined with more specialized study. Whether pursuing careers in education, law enforcement, business, the horse industry, social work, education, or the arts, Centenary students leave here ready to compete and succeed in a quickly changing and increasingly global society.

The story of Centenary College chronicled in this book is hardly finished. For 145 years, it has been a vital part of the history of Hackettstown, and without the generosity and support of its residents throughout the years, the college would not have survived. It has also been a part of the history of northwestern New Jersey. The wish of all of us at Centenary is that the golden dome will continue to shine as a beacon of educational excellence for many decades to come.

One

BEGINNINGS
1869–1898

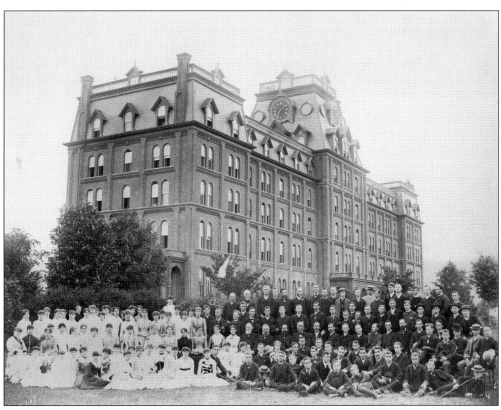

The cornerstone of Centenary Collegiate Institute was laid on September 9, 1869. The Newark Conference chose the Hackettstown site because "it is one-fourth of a mile from depot and Church, post office and shops and stores of a prosperous country town." Ten prominent citizens in the town came forward and donated a total of $10,000 and 10 acres of land. Pictured in front of the original building are members of the class of 1885.

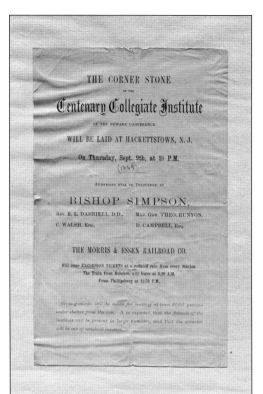

THE CORNER STONE

OF THE

Centenary Collegiate Institute

OF THE NEWARK CONFERENCE

WILL BE LAID AT HACKETTSTOWN, N. J.

On Thursday, Sept. 9th, at 2½ P.M.
(1869)

ADDRESSES WILL BE DELIVERED BY

BISHOP SIMPSON,

REV. R. L. DASHIELL, D.D., MAJ. GEN. THEO. RUNYON,

C. WALSH, ESQ., D. CAMPBELL, ESQ.

THE MORRIS & ESSEX RAILROAD CO.

Will issue EXCURSION TICKETS at a reduced rate from every Station.
The Train from Hoboken will leave at 8.20 A.M.
From Phillipsburg at 12.53 P.M.

Arrangements will be made for seating of at least 2000 persons
under shelter from the sun. It is expected that the friends of the
Institute will be present in large numbers, and that the occasion
will be one of unusual interest.

The fledgling college was having problems raising money, but enough was on hand to lay the cornerstone of the new building. Special excursion trains were provided as well as seating for 2,000 visitors. The cornerstone was recovered from the ruins of the 1899 fire and can be seen today on the northeast corner of the present Edward W. Seay Administration Building.

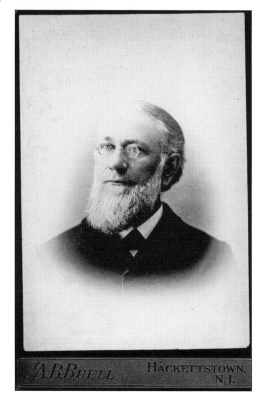

A.B.BUELL HACKETTSTOWN, N.J.

On September 9, 1874, at the opening ceremonies of the new building, George H. Whitney was officially inaugurated as the first president of Centenary, although he had already held the office for five years. During that time, he had worked tirelessly raising funds, preparing the curriculum, and recruiting students. He would serve as president until 1895.

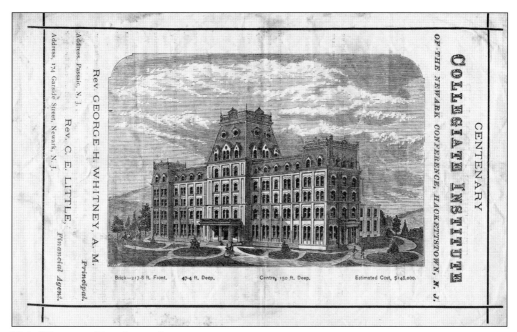

This "Trustees Circular to the Contributors and Patrons of the Collegiate Institute" was a brochure sent to members of the Newark Conference of the Methodist Church in early 1874 to raise money to complete the main building's construction. Over $78,000 had been raised by 1873, but another $32,000 was needed. The trustees stated, "We long since determined that the building should not, when completed, be embarrassed by debt."

This promotional material for prospective students was produced around 1884. A photograph of the main building was printed on the back.

Centenary Collegiate Institute.

(NEWARK CONFERENCE SEMINARY.)

REV. GEORGE H. WHITNEY, D. D., President.

HACKETTSTOWN, N. J. (Near Schooley's Mountain).

Ladies' College. College Preparatory for Gentlemen. Fourteen Professors in the Faculty.

The edifice is spacious and elegant; heated by steam, lighted with gas; mountain spring water, both hot and cold, on each floor; accommodates 200 boarders.

ELEVEN COURSES OF STUDY.

1. Academic (2 years); 2. Collegiate, for gentlemen (three years, with diploma); 3. Belles-Lettres Course for Ladies (with Degree of M. E. L.); 4. Classical College Course for Ladies (with Degree of M. L. A.); 5. Latin Scientific Course (with diploma); 6 Special Course; 7. Theological (for those preparing for Theological Seminaries); 8. Course in Music; 9. Course in Art; 10. Course in Elocution; 11. Commercial Course.

The Institute was opened September 9, 1874, with about two hundred students, and it has had unusual and continued prosperity. For several years students have been refused from lack of room SEND FOR CATALOGUE.

A more elegant and substantial educational building we have yet to find. The location is unsurpassed, * * * The establishment cost $200,000 and is free from debt. Its few years of history have been years of almost unexampled prosperity, and any of the readers of the *Christian at Work* who visit this grand school will not wonder that its halls are so generally crowded.—*Editorial in the Christian at Work* (1884).

The President of the Institute, Dr. Whitney, had the organization of this great school from the laying of the corner-stone till its formal opening, since which time he has had the pleasure of seeing the enterprise growing continually in strength and influence, taking rank as superior to most and second to none of the Collegiate Institutes of the land. * * Because the building and equipments of the school are the free gift of the people, the trustees are enabled to offer board and tuition at the exceedingly low rate of $225.00 per year.—*New York Daily Graphic.*

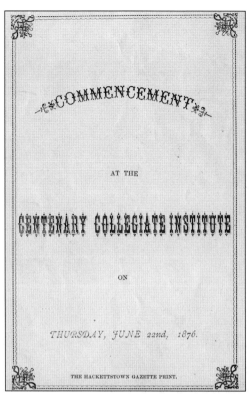

COMMENCEMENT

AT THE

CENTENARY COLLEGIATE INSTITUTE

ON

THURSDAY, JUNE 22nd, 1876.

THE HACKETTSTOWN GAZETTE PRINT.

The commencement program for the first graduating class of Centenary Collegiate Institute in 1876 listed 26 students—12 women and 14 men.

Members of the class of 1886 are pictured on the front lawn, with President Whitney seated in the center. At that time, the Ladies' College granted two degrees: a four-year Mistress of Liberal Arts and a three-year Mistress of English Letters. The men were enrolled in a College Preparatory for Gentlemen, graduating in three years.

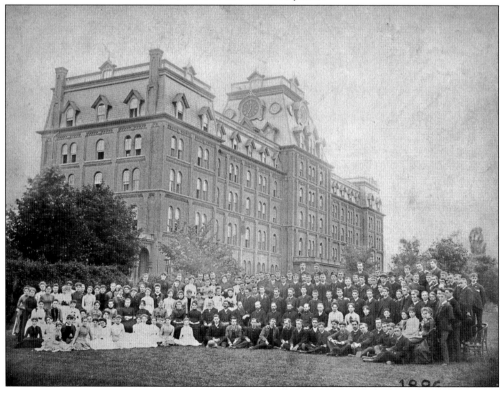

The Whitney Lyceum was a literary society formed by five male students "for mutual improvement and practical utilization of the forces acquired in the daily class drill." Dr. Whitney gave his enthusiastic approval. Most members were preparing to enter the ministry, but soon any "earnest, purposeful young men" were encouraged to join.

INAUGURATION

OF THE

Whitney Lyceum,

IN THE CHAPEL OF

Centenary Collegiate Institute,

HACKETTSTOWN, N. J.

FRIDAY, FEB. 26, 1875, AT 7:30 P. M.

La Monte G. Raymond, Printer.

A baseball game is in progress on the rear lawn around 1890. The large structure on the far right is the present Ferry Building. Along with the adjacent Little Theater (both were gymnasiums at the time), they are the only surviving structures from that time.

22ND ANNIVERSARY
DIOKOSOPHIAN SOCIETY
FEB. 19TH 1897.

The women wanted their own literary societies and formed two: the Dioksophian Society in 1875 and the Peithosophian Society four years later. They helped students improve their writing and speaking as well as their skills in music and dramatics and included social activities. Along with athletics, membership in these societies was considered an essential part of campus life.

"ATHA SINE LITTERIS MORS EST."

1874-1884

NINTH ANNIVERSARY

OF THE

Philomathean Fraternity
(HACKETTSTOWN CHAPTER)

Centenary Collegiate Institute,

FRIDAY EVENING, JUNE 13th,

1884

Every fraternal society on campus had a yearly celebration of their founding. These consisted of orations and recitations, musical selections, singing, and the reading of essays.

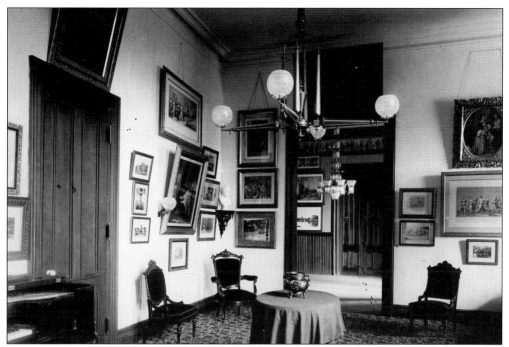

Original images of the interior of the main building are rare, as most were destroyed in the fire of 1899. This is a photograph of the front parlor, taken around 1880. Note the gas lamps on the ceiling.

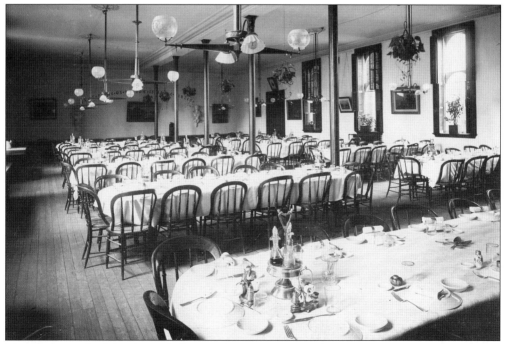

This photograph of the dining hall was taken in 1895. Note the combination of gas and electric lights. The entire building was originally illuminated by gas lamps, which were gradually replaced by electric lamps as the use of indoor light bulbs became more common.

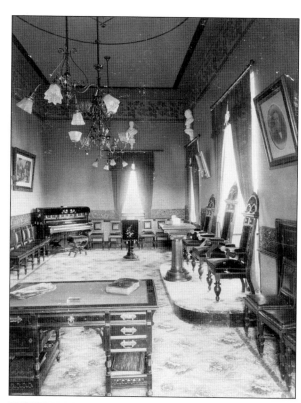

Fraternal societies were given rooms in which to meet and socialize. The Whitney Lyceum met in this room in 1895.

This is a rare photograph of a female student's dormitory room, taken in 1899. The original main building housed student rooms, classrooms, chapel, library, and dining hall.

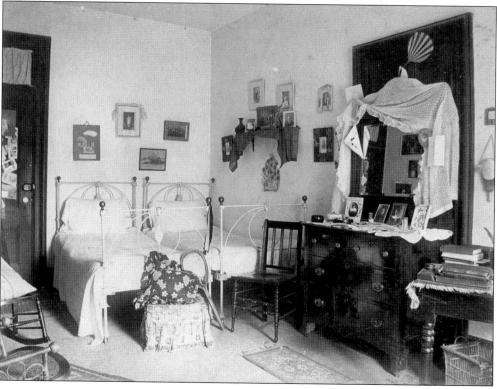

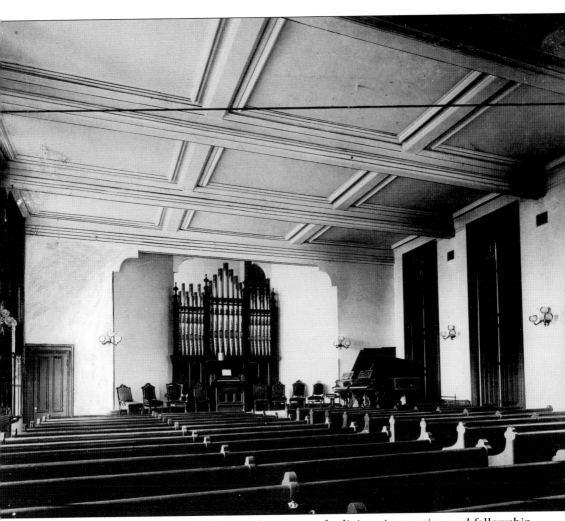

The chapel, shown here in 1880, was the center of religious instruction and fellowship. Services were held on Sunday afternoons and evenings. On Sunday mornings, the female students marched two by two down Church Street to services in the Trinity Methodist Church on Main Street in Hackettstown, accompanied by faculty members at the front and rear of the line. They were followed by the male students. The Sunday evening campus service was held in the CCI chapel and was led by a faculty member. During the week, "prayer and praise" services were here held each day, followed by Saturday services as well. Attendance was strongly encouraged but not mandatory, and most students regularly participated. Dr. Whitney wrote in his autobiography, "I determined that our 'Chapel Exercises' should be as attractive and profitable as possible. . . . I never in all my years' stay heard that students considered them to be a bore."

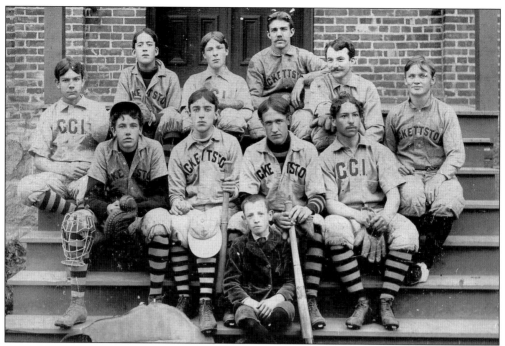

"Two splendid fields have been set aside for outdoor sports," states the 1896—1897 college catalog. Centenary had 10 tennis courts as well as a baseball diamond and football field. This is the CCI baseball team in 1896. The sport continues to be popular among students today.

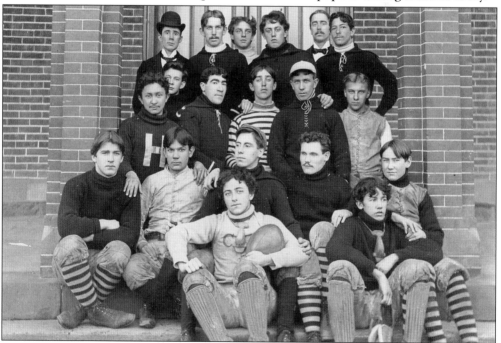

Pictured here is the 1894 football team. They would play against other preparatory schools in northwestern New Jersey and eastern Pennsylvania. The catalog notes that "strong teams in football and baseball have scored many victories."

Dr. Whitney (center) poses with his last graduating class in 1895. He served 21 years as Centenary's first president. On April 30, 1895, Dr. Wilbert P. Ferguson from Toronto, Canada, succeeded him. It was customary for students in the class picture to pose in wild costumes or strange attire, or to be holding odd objects or signs. Whitney was always a good sport about this but does not appear amused here.

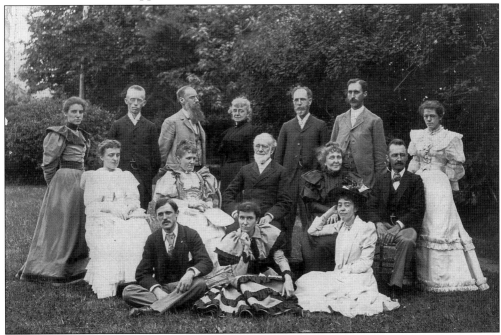

President Whitney (center) poses with the CCI faculty in 1896. The third member from the left, standing in the third row, is Prof. Albert O. Hammond, who taught history at CCI for 40 years. In 1917, he wrote an unpublished history of the college, which remains a valuable source of information on Centenary's early years.

CCI celebrated its 20th reunion in 1894 in Ocean Grove, New Jersey. This shore community was established as a camp meeting site by the Methodist Church in 1869. The college held reunions there every five years. Notice that the price for the banquet was $1 per plate.

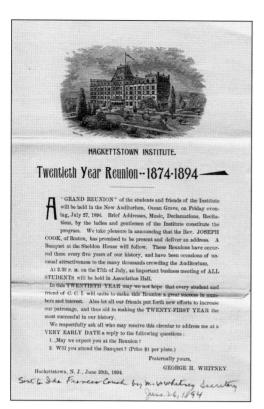

HACKETTSTOWN INSTITUTE.

Twentieth Year Reunion -- 1874-1894

A "GRAND REUNION" of the students and friends of the Institute will be held in the New Auditorium, Ocean Grove, on Friday evening, July 27, 1894. Brief Addresses, Music, Declamations, Recitations, by the ladies and gentlemen of the Institute constitute the program. We take pleasure in announcing that the Rev. JOSEPH COOK, of Boston, has promised to be present and deliver an address. A Banquet at the Sheldon House will follow. These Reunions have occurred there every five years of our history, and have been occasions of unusual attractiveness to the many thousands crowding the Auditorium.

At 2.30 P. M. on the 27th of July, an important business meeting of ALL STUDENTS will be held in Association Hall.

In this TWENTIETH YEAR may we not hope that every student and friend of C. C. I. will unite to make this Reunion a great success in numbers and interest. Also let all our friends put forth new efforts to increase our patronage, and thus aid in making the TWENTY-FIRST YEAR the most successful in our history.

We respectfully ask all who may receive this circular to address me at a VERY EARLY DATE a reply to the following questions:

1. May we expect you at the Reunion?
2. Will you attend the Banquet? (Price $1 per plate.)

Fraternally yours,

GEORGE H. WHITNEY.

Hackettstown, N. J., June 20th, 1894.

Sent to Ida Frances Couch by M. W Whitney Secretary
June 26, 1894

CENTENARY COLLEGIATE INSTITUTE,
(Newark Conference.)

HACKETTSTOWN, N. J.

REV. WILBERT P. FERGUSON, B. D., President.

We respectfully call attention to some of the advantages of our school:

The Location, among the mountains of Northern Jersey, 56 miles west from New York City, is one of extraordinary beauty, and is specially noted for healthfulness. It is reached by the Delaware, Lackawanna & Western R. R.

The Building is considered the finest of its class, and is kept in perfect repair. It is heated by steam, lighted by electric lights, and supplied throughout with an abundance of the purest mountain spring water. The house is appropriately furnished, rooms are carpeted, and every bed has new woven wire springs. No DEBT exists on our entire property, which is now valued at $230,000.

This admissions brochure was printed in June 1895. The new president notes that "the school has gained wide reputation as a College and Business Preparatory for young men, and as a Ladies' College of the first rank."

The last graduating class of the "old Centenary"—before the tragic main building fire—was the class of 1899, celebrating the 25th anniversary of the beginning of classes. The school year opened with much optimism. Enrollment was strong; an elevator was installed in the main building. Plans were being drawn up for a house for the president and a new library and chapel. "The future of the school never appeared better," wrote Ernest Rockwell Dalton in his unpublished 1982 history of Centenary. No one in June 1899 had any idea of the incredible catastrophe that would befall the college in a few short months.

Commencement Exercises

..OF THE..

Class of Ninety=Nine

..OF THE..

Centenary Collegiate Institute,

Hackettstown, N. J.

WEDNESDAY, JUNE FOURTEENTH,
Eighteen Hundred and Ninety-Nine.

TWENTY=FIFTH

ANNUAL COMMENCEMENT

....OF THE....

Centenary Collegiate Institute,

HACKETTSTOWN, N. J.

JUNE 9--14, 1899.

The best-known story from Centenary's early years is the murder of Tillie Smith, a kitchen maid at CCI in the 1880s. She was killed on the night of April 8, 1886, and her body was found the next morning behind the main building. Charles Titus, the school's janitor, became the prime suspect and was arrested on April 29. The four-week trial caused a sensation in northwest New Jersey and was followed by the major New York newspapers. Titus maintained his innocence but eventually pled guilty to avoid the death penalty. He was sentenced to life but released in 1904, quietly living the remainder of his life in Hackettstown, not far from the Centenary campus. Local author Denis Sullivan, in his excellent book about the murder and trial, concluded that Titus was an innocent man. Over the years, many Centenary employees and students have reported seeing or hearing the ghost of Tillie in campus buildings late at night. The residents of Hackettstown erected a large monument at her gravesite in a nearby cemetery, where to this day students frequently leave flowers, beads, and candles.

22

Two

TRIAL BY FIRE
1899–1916

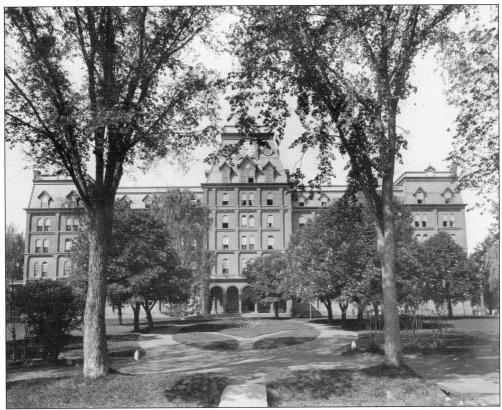

This is probably the last photograph taken of the old main building before it was destroyed by fire a few months later. The June 1899 commencement celebrated CCI's 25th anniversary. Six original members of the board of trustees as well as members of the original contracting company were honored, as were some of the Hackettstown residents who donated the land.

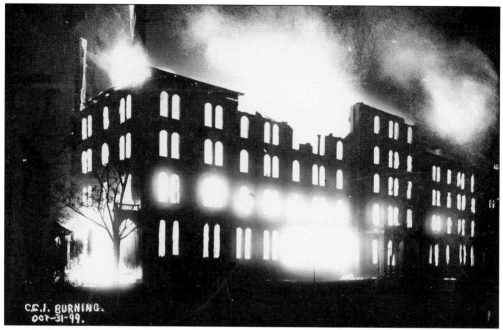

On the night of October 31, 1899, a fire began in the basement of the main building. Painters had been working in rooms during the day and stored their supplies near the boiler room. Spontaneous combustion was suspected to be the likely cause of the fire, but the true cause was never determined.

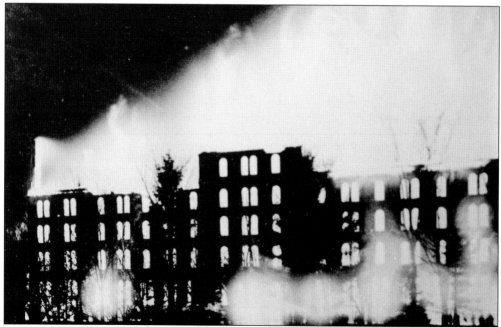

There were 215 students, faculty, and staff members in the building that evening. Miraculously, all escaped unharmed. The heroine of the night was Charlotte Hoag, "preceptress" (dean) of the women students, who marched 66 girls in nightclothes and bathrobes to the safety of the men's gymnasium, calling the names of each one from memory.

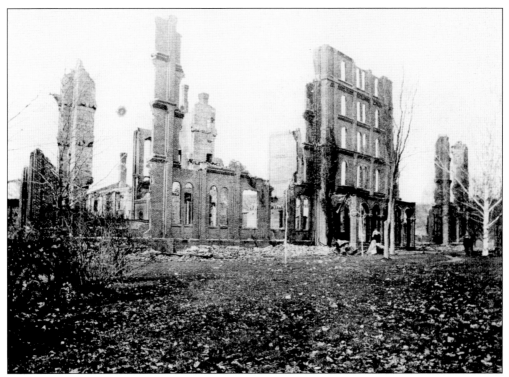

Shortly after midnight, it was clear that the building was gone. As if sounding its own death knell, the clock tower struck 2:00 a.m. and collapsed into the inferno below with a tremendous roar. Tearful spectators stood by helplessly as flaming floors fell to the ground. By morning, a few walls and a smoldering pile of debris were all that remained.

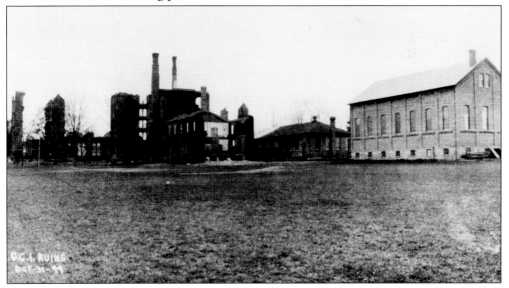

This view of the ruins from the rear of the building was taken the morning after the fire. The two gymnasiums (now the Little Theater and the Ferry Building) and the college barn were the only structures to escape the flames. A sudden shift in the wind that night had spared them.

Announcement.

The Centenary Collegiate Institute hopes to be able to resume the session of the Fall term sometime next week, provided parents and guardians will consent to the care of the students in private families. As far as possible, large homes will be secured where a teacher will live in charge. The citizens of Hackettstown are willing to make large sacrifices in order to secure the early return of our happy and ambitious young people. The aggregate cost for Board, Tuition, Light, Heat and Laundry, ought not to exceed the regular annual charge made by the Institute. In special cases the cost may be made even less than the usual. The Presbyterian Chapel will afford the necessary class rooms. Every possible provision for the comfort, the safeguarding, and the instruction of young people will be offered. After investigating many hotel properties, we find that the conditions named are the only conditions under which school work could be safely resumed. We believe these conditions can be made satisfactory to our patrons, for many of the best homes of Hackettstown have been placed at our disposal. The balance due patrons will be appropriated, with their consent, to caring for their children throughout the Fall term. An IMMEDIATE REPLY to this circular is desired and imperatively needed in order that we may know at once how many students we will have to provide for. Please give this matter prompt attention.

We thank our patrons for past favors, and for their kindness and calmness at the time of our calamity. We may add that there is no doubt that the Institute will be rebuilt with all possible haste, and on an improved plan. C. C. I. must arise from this disaster to a life more prosperous and glorious than its past.

WILBERT P. FERGUSON,
President.

Hackettstown, N. J., November 7th, 1899.

President Ferguson was visiting relatives in Toronto at the time of the fire. Prof. Charles McCormick took over as acting president until his return. He assembled students and faculty in the Trinity Methodist Church downtown. Some decided to go home. Hackettstown residents generously opened their homes to students who chose to remain, providing food, clothing, and lodging, as most had lost everything in the fire. In a letter of appreciation to the townspeople, Dr. Ferguson recalled the biblical verse from St. Paul: "Cast down but not destroyed." He was determined that somehow classes would resume as soon as possible. Most students returned a few weeks later. The chapels of the nearby Methodist and Presbyterian churches were turned into temporary classrooms. In this letter of November 7, Ferguson boldly asserts "that there is no doubt that the Institute will be rebuilt with all possible haste. . . . C.C.I. must arise from this disaster . . . more prosperous and glorious than its past." But on January 24, 1900, President Ferguson suddenly resigned. Charles Wesley McCormick left his faculty position to become Centenary's third president.

On November 23, 1899, just three weeks after the fire, George J. Ferry, president of the CCI board of trustees for the past 26 years, pushed for a resolution from the Newark Methodist Conference to rebuild. He was joined by George H. Whitney, who had come out of retirement to offer assistance. The two men would work tirelessly to secure funds for a new building.

The Centenary football team poses on top of the ruins. The goat is undoubtedly their mascot. The African American member of the team, standing in the back row on the left, may be the first black student to be enrolled at Centenary.

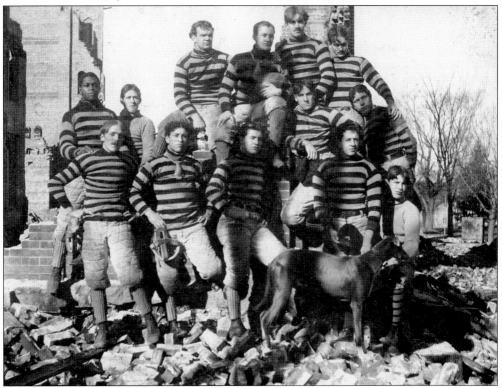

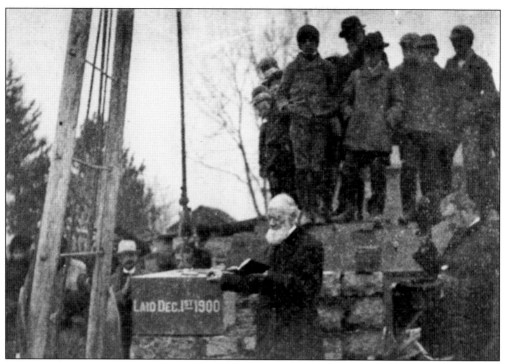

On December 1, 1900, Dr. Whitney presided over the laying of the cornerstone of the new building. The college collected $116,000 in insurance money, and the Newark Conference resolved that a new structure be built at a cost not to exceed $250,000. Oscar S. Teale, who had designed over 20 churches and 14 schools in New Jersey, would be the architect. Teale was also known for designing the cemetery memorial of Harry Houdini, the famous magician and escape artist. This would be his largest building, and it received more press coverage than any of his projects. A time capsule was installed inside the cornerstone, into which were placed, among other items, a Bible, a Methodist hymnal, pictures of the original building, including a picture of Dr. McCormick's daughter (age seven) laying the first stone in the foundation of the new structure, a CCI catalog of 1899–1900, and copies of local newspapers. Attempts to safely open it on the 100th anniversary, December 1, 2000, were unsuccessful. The red sandstone cornerstone of the original building rests to the left of the new stone.

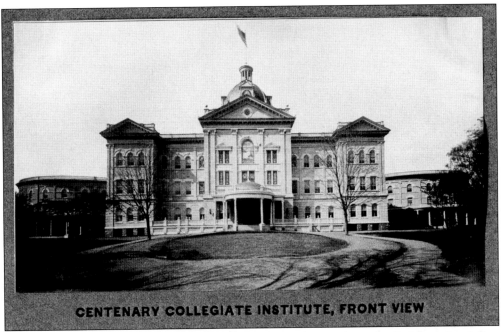

CENTENARY COLLEGIATE INSTITUTE, FRONT VIEW

Construction of the new building proceeded at a rapid pace. A nearby freight train station made possible the speedy delivery of needed materials. Incredibly, classes were held in the new structure on September 23, 1901, just under 10 months after the rebuilding began. On December 5, 1901, the new building was finished and formally dedicated by Dr. Whitney.

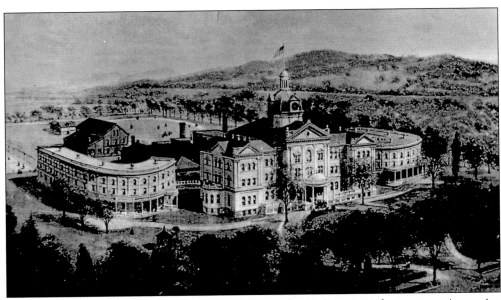

The new building's design was radically different from the original structure. A massive copper-clad dome rose 122 feet into the air. Underneath, a magnificent chapel with stained-glass windows and a balcony defined its center. To the left and right of "Old Main" were two curved dormitory buildings, then called North and South Halls. People marveled at the fine detail and craftsmanship as well as the building's scale, complexity, and beauty.

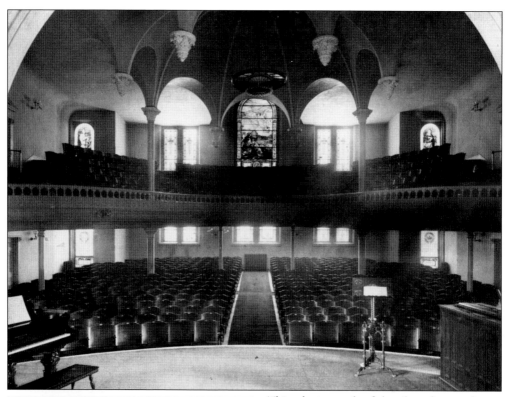

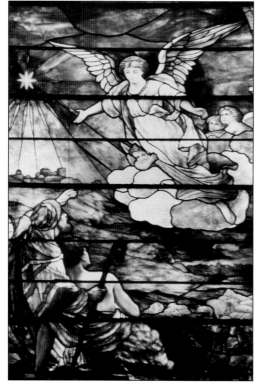

This photograph of the chapel was taken from the front platform, facing toward the front of the building. The stained-glass windows on the rear wall were gifts from former students and their parents. A new pipe organ was donated by a student of the class of 1883.

The central chapel window illustrates the birth of Christ, depicting the star in the East and the appearance of an angel. It was a gift from a Hackettstown woman, whose daughter attended Centenary, and her sister from Newark, whose grandson was a student.

This photograph of the chapel was taken from the rear, facing the platform. It was officially named Whitney Chapel to honor Dr. Whitney's tireless fundraising efforts to see it completed.

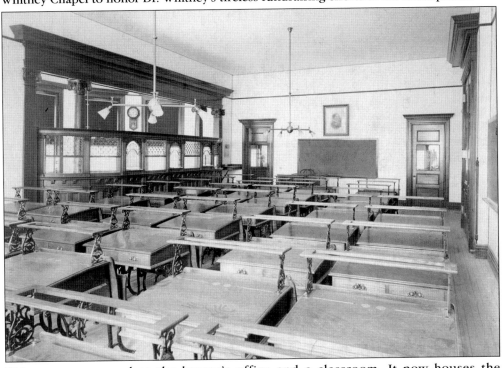

This room was used as the bursar's office and a classroom. It now houses the admissions office.

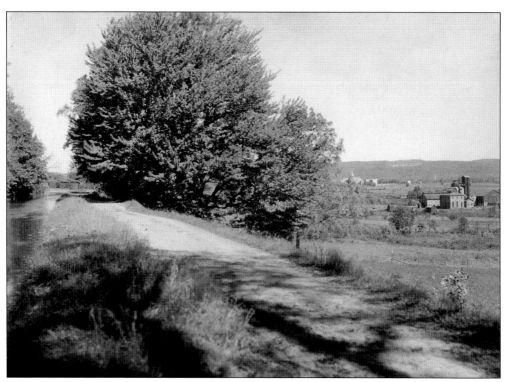

In 1903, the New Jersey State Legislature was considering abandoning the Morris Canal, which was essentially put out of business by the railroads. A written report was prepared, along with a photographic supplement containing 91 pictures taken along the entire length of the canal from Phillipsburg to Jersey City. Two remarkable photographs were taken as the photographers passed through Hackettstown. The above photograph was taken on the canal towpath, south of the campus near Rockport Road. The dome of the main building can clearly be seen just to the right of the trees. The photograph below was taken from the roof of the main Centenary building next to the dome, looking north toward Panther Valley and capturing the surrounding neighborhood in front of the college. The canal is in the upper left of the photograph. (New Jersey State Archives, Department of State.)

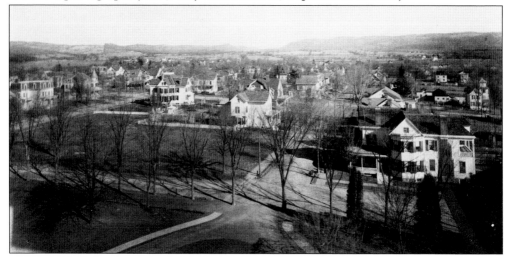

Outdoor sports continued to be an important part of life at CCI. This 1903 photograph shows a baseball diamond in the area of the present quad at the rear of the main building.

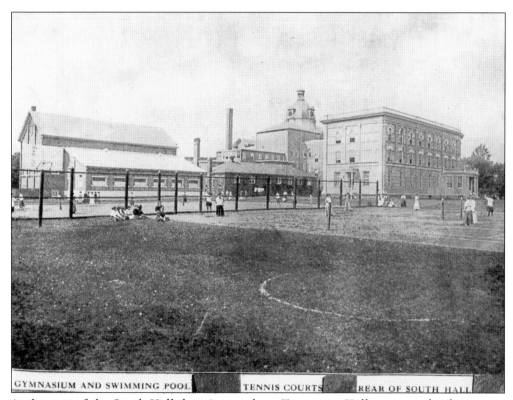

GYMNASIUM AND SWIMMING POOL TENNIS COURTS REAR OF SOUTH HALL

At the rear of the South Hall dormitory, where Trevorrow Hall now stands, there were tennis courts. The gymnasium and swimming pool were located in what is now the Ferry Building.

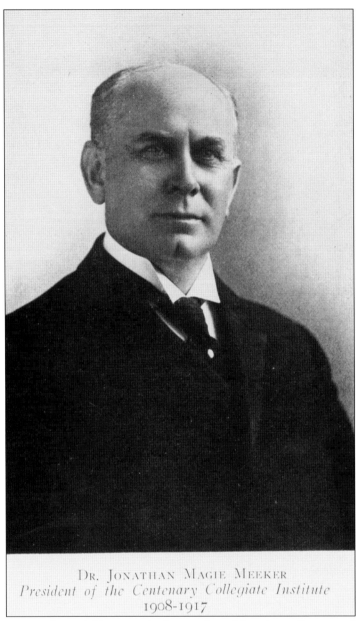

Dr. Jonathan Magie Meeker
President of the Centenary Collegiate Institute
1908-1917

In 1908, there was a substantial increase in the number of female applicants and a decrease in male applicants to CCI. Discussions soon began about converting to a single-sex institution. In December 1909, Pres. Jonathan Meeker presented a written report to the board of trustees proposing that coeducation be abolished, beginning with the 1910 academic year. Following the decision, in an open letter to "Our Alumni and Friends," he argued that "the physical and psychological considerations, as well as the consensus of opinion among prominent educators, convinced the Trustees and the administration that better results could be obtained in a single sex school. . . . Many colleges and schools have made the change to their advantage and others are preparing to do so. Parents are less inclined than formerly to send their children to a coeducational school." The men would not return to the traditional, full-time academic programs until 1988, seventy-eight years later.

This is the first brochure advertising Centenary as "A School for Girls." Inside, President Meeker urges prospective students and their parents to visit the school: "A patron assured me that of the twenty schools he had visited, there was but one of them comparable to this, but it was far more expensive."

The primary reason for the switch to single-sex education was financial, as evidenced by this fundraising letter. A headline in the *Newark Evening News* in 1916 read, "Centenary in Bad Financial Straits." The article said that "[Centenary] is in dire financial straits, and unless a prompt turn for the better is taken, its future is in doubt."

35

This photograph shows the last coeducational class at CCI. The college catalog made no announcement of the change, although the name of the institution was given as "Centenary Collegiate Institute for Girls."

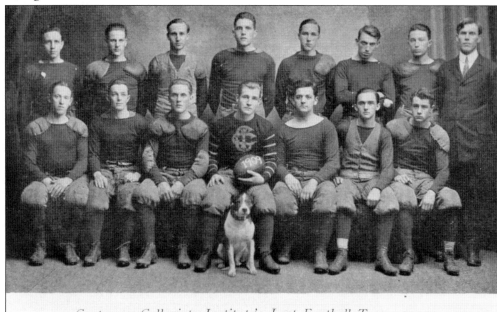

Centenary Collegiate Institute's Last Football Team, 1909
Standing, left to right: Whittle, Kidney, Thompson, Lansing, Seger, Johnston, Buckley, Coach Denman; Seated, left to right: Hockenbury, Penny, Snedecor, Capt. Gregory, Woolley, Wade, Kidd.
"Togo."

CCI's last football team was from the class of 1909. Even after men returned in 1988, football as a college team sport did not.

Three

FROM COLLEGIATE INSTITUTE TO JUNIOR COLLEGE
1917–1944

Robert Johns Trevorrow became Centenary's sixth president in 1917. Enrollment was at an all-time low of 72 students, and the college was $80,000 in debt. There was talk of a possible merger with nearby Drew University. The trustees knew they needed a strong leader and excellent administrator if the college was to survive. They found that person in Dr. Trevorrow.

President Trevorrow immediately went to work to raise funds for the school. His inauguration would also serve as a reunion event. "Anything that will cement old friendships and make new ones is important to our school," he wrote in 1917.

633　　G　　1926

The president saw marketing and advertising as keys to bringing Centenary back to financial health. Advertisements such as this one were printed in newspapers in New York, New Jersey, and Pennsylvania.

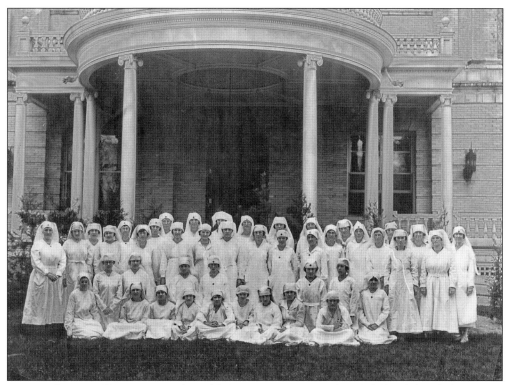

In 1917, the United States entered World War I. Centenary students pledged their help toward the war effort. This is a photograph of a Red Cross training class taken in 1918, when 50 students and faculty members earned first aid certificates.

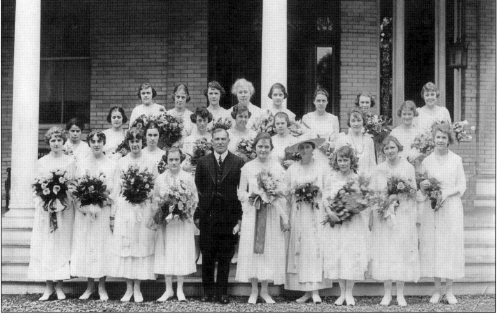

President Trevorrow poses with the graduating class of 1918 on the front lawn of the main building.

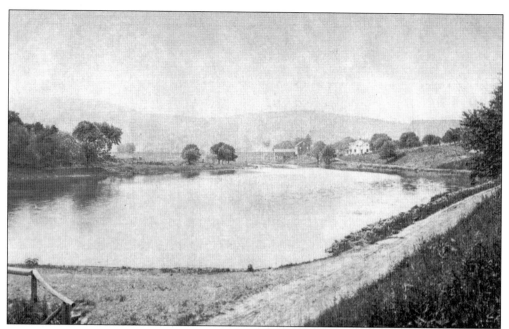

In 1913, Centenary sold the water rights to the school lake to the New Jersey Fish and Game Commission to construct a fish hatchery. In exchange, the college gained an entrance to the campus on what is now Reese Avenue and 20 building lots that could be sold later on.

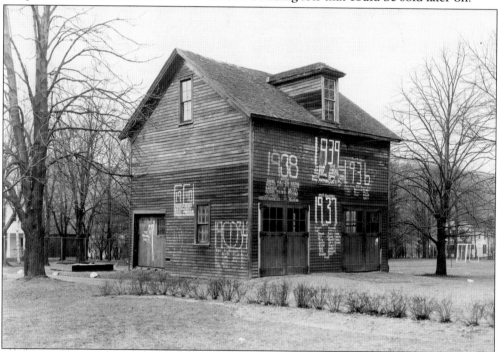

In 1906, the college purchased 118 acres behind the campus and maintained a working farm. By the 1920s, the farm was no longer profitable, and President Trevorrow decided to sell the land to help pay down the college's debt. For many years, the "Old Barn" stood at the location of the present gymnasium and was all that remained of the memory of the farm.

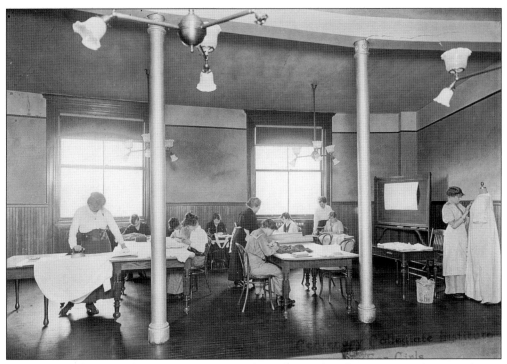

In this 1921 photograph, students are at work in the sewing department. Classes in home economics would later allow students to work toward New Jersey teacher certification.

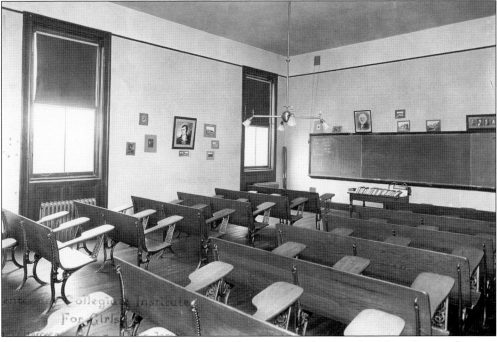

This 1922 photograph shows a recitation classroom in the main building. Except for new furniture, whiteboards instead of slate blackboards, and technology, the room today looks very much as it did back then.

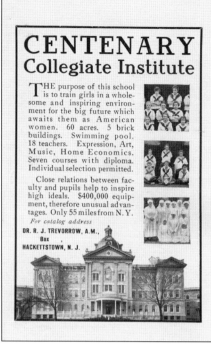
The college continued to market aggressively throughout the 1920s, and enrollment steadily increased each year. Dr. Trevorrow also raised tuition from $500 to $850. By the spring of 1921, the college was able to pay off $37,500 of its debts. In Trevorrow's seven years as president, $81,000 was raised to pay off the remaining mortgage on the new building. By 1926, enrollment had risen to 187 students. In future years, enrollment would be capped at 160 students.

Centenary celebrated its 50th anniversary in 1924. In an event at the school, President Trevorrow ceremonially burned the school mortgage to signify that it had been paid in full.

The Bulletin of

Centenary Collegiate Institute

Hackettstown, New Jersey

ROBERT J. TREVORROW, President

50th Anniversary

and

Alumni Day

June 7, 1924

Vol. VII JANUARY, 1924 No. 1

Entered as second class matter, April 17, 1918, at the Post Office at Hackettstown, N. J., under act of Congress, August 24, 1912.

Dr. Trevorrow presents the check to pay off the school mortgage to the trustees on February 15, 1924.

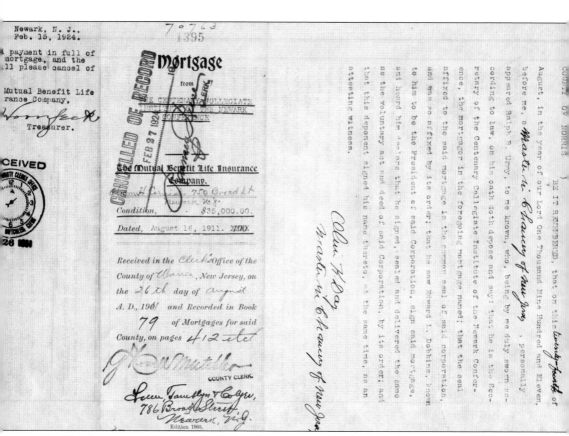

In this photostat of the cancelled school mortgage, the clerk's "Cancelled of Record" stamp on the document is dated February 27, 1924.

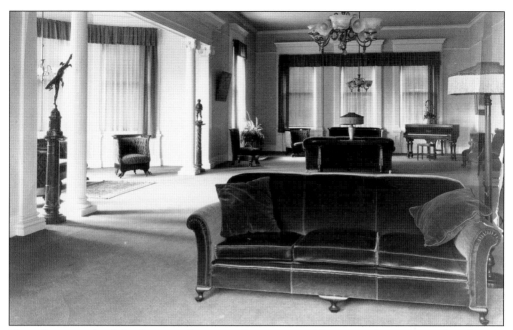

This photograph of the front parlor was taken in 1925. This room has remained a place to welcome visitors and host special college events.

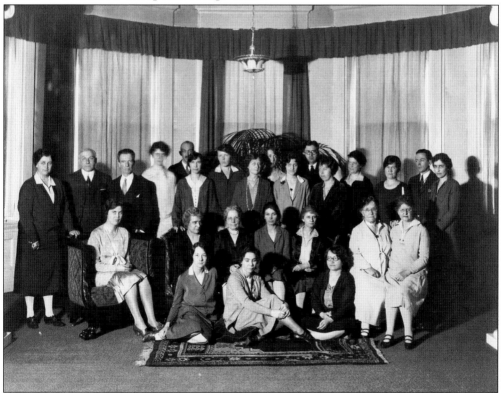

President Trevorrow, second from the left in the second row, poses with the Centenary faculty in 1927.

Now that the college was on a firm financial footing, three plans for future growth were considered: keep the college as it was, become a four-year liberal arts college for women, or become a junior college for women. There was no plan to return to coeducation. Since there was no college for Protestant women within 200 miles of CCI and a growing need for more institutions of higher learning in New Jersey, the decision was made to become a junior college. Major changes in the curriculum were undertaken, and new faculty were hired. On September 24, 1929, Centenary Junior College opened with 47 new students. President Trevorrow envisioned 250 students—"big enough to command attention, small enough for personalized care and instruction." "I often wondered," he told the trustees, "what the future will think of us and our plans."

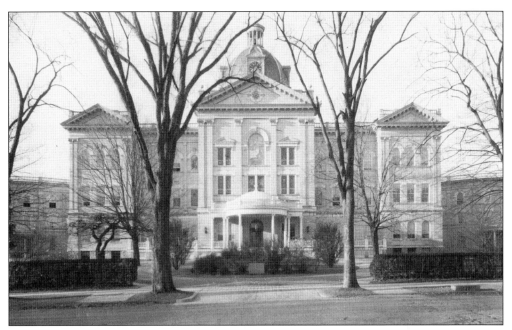

This is a front view of the main building, taken in 1932.

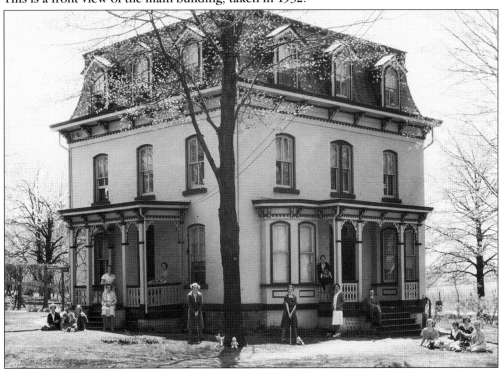

The Faculty House was built in the 1870s and was later named DuBois Hall, in honor of H. Graham DuBois, a faculty member from 1929 to 1965 who lived in the house for many years. To make room for Brotherton Hall, it was moved to where the rear portion of the gym now stands. It later housed the college development office, fell into disrepair in the 1990s, and was demolished in 2000. This photograph was taken in 1932.

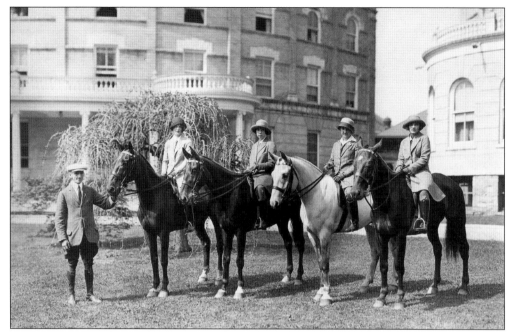

Horses have been a part of life at Centenary for many years. These students are taking riding lessons on the front lawn of the campus in 1926. After the summer vacation season ended, a resort operator in nearby Budd Lake would board his horses in town for use by Centenary students.

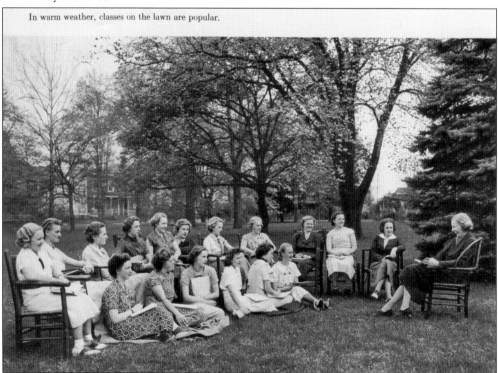

In warm weather, classes on the lawn are popular.

Students enjoy a class on the front lawn on a warm spring day in 1936.

48

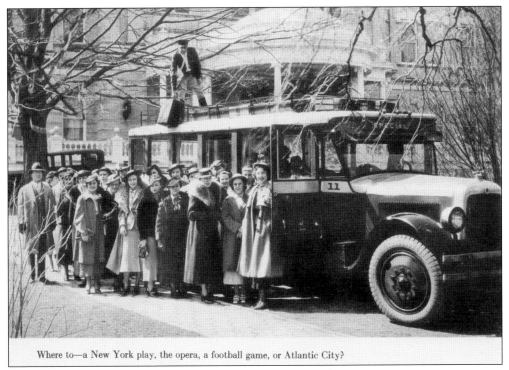

Where to—a New York play, the opera, a football game, or Atlantic City?

For students, one of Centenary's great advantages was its location. Bus excursions were a popular activity in the 1930s.

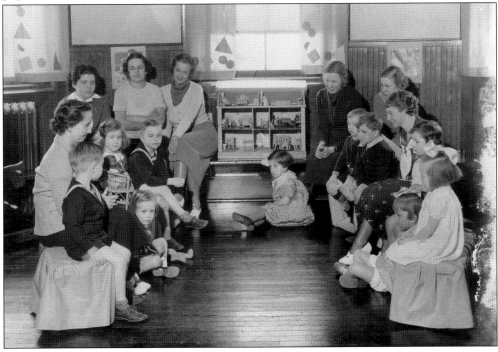

Centenary began a nursery school on campus in 1936. The school was in continuous operation until 1999, when it was closed to make room for classrooms and faculty offices.

Bette Cooper, a student at Centenary who lived in Hackettstown, entered the 1937 Miss America contest on a dare from her friends. After winning the competition, however, she became overwhelmed and disappeared with her pageant chaperone. Newspapers ran photographs showing the empty throne. When she returned 24 hours later, she and her family demanded and received a less rigorous tour schedule so she could return to Centenary and finish her degree. This led to a permanent change in the pageant's rules. Bette Cooper graduated in 1939.

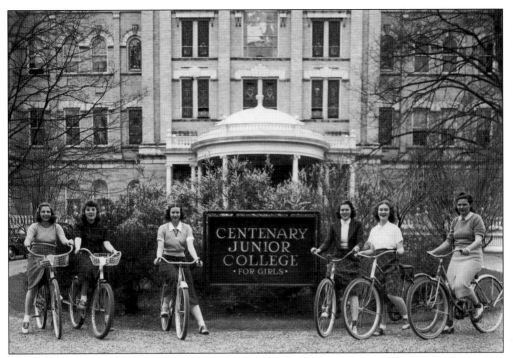

In 1940, Centenary Collegiate Institute officially became Centenary Junior College. The secondary school and the academy were phased out, as were most certificate programs. Students would now earn an associate degree in their field of study.

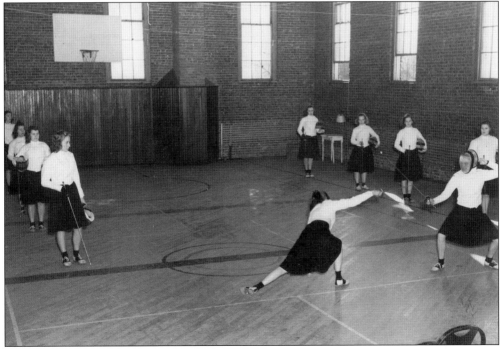

What is now classroom space in the Ferry Building was once the college gymnasium. A fencing class is in session there in 1941.

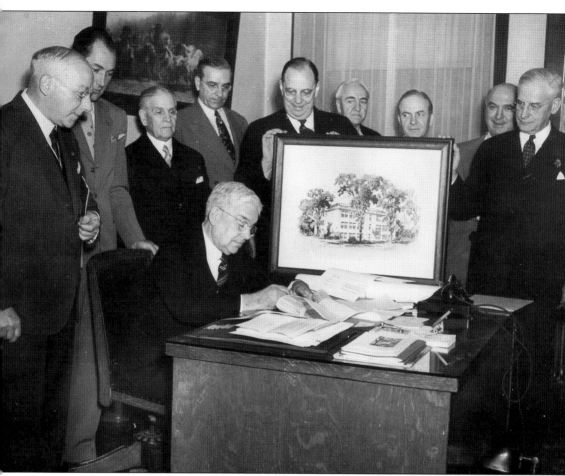

President Trevorrow (far left) looks on as Charles E. Lotte, chair of the board of trustees, signs the contract for the construction of what was called the "New Building," June 8, 1940. Construction would begin two days later, and the building would be finished in May 1941. The total cost was $100,000. It would contain laboratories and classrooms designed, the president said, "to round out the students' education in chemistry, biology, painting, sculpture and domestic arts."

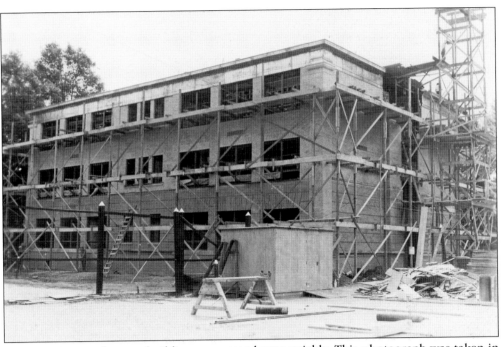

Construction on the new building progressed very quickly. This photograph was taken in the late summer of 1940.

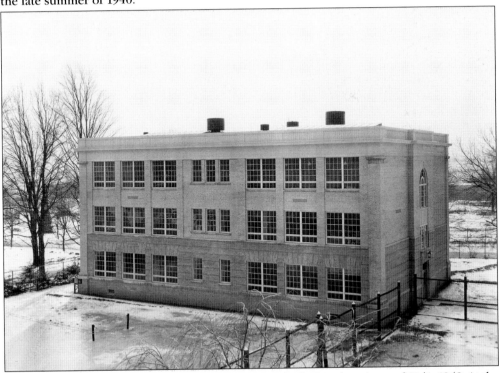

This photograph shows the completed building as it looked in the winter of 1941–1942. At the 1941 commencement, the building would be named Trevorrow Hall, in honor of President Trevorrow and his wife, Editha, who had given so much to the college.

The BULLETIN of

Centenary Collegiate Institute

HACKETTSTOWN - NEW JERSEY

ROBERT J. TREVORROW, A. M., D. D.
President

IN MEMORIAM

President Robert J. Trevorrow

Volume XXVI - Number 1

February, 1943

Issued four times yearly by Centenary Collegiate Institute

Entered as second class matter, April 17, 1918, at the Post Office at
Hackettstown, N. J., under act of Congress, August 24, 1912

President Trevorrow's health had been in decline for some time. His doctor diagnosed a "weak heart" in 1939, the first year he was unable to lead the commencement ceremony. He also had to give up his favorite game of golf. Maintaining a demanding schedule until the end, he rarely missed the daily chapel services and the Sunday Vespers service, where students would come and listen to his inspiring talks. On January 25, 1943, he gave his last Sunday sermon. "Carry on!" he told the students, as if knowing his end was near. "Make the most of yourselves, for your own sakes, for your country's sake." One week later, he died of a heart attack in his home. Trevorrow had been Centenary's president for 26 years, leading the college successfully through difficult financial times as well as the transition from a collegiate institute to a junior college.

Editha Trevorrow would take her late husband's place at the helm until a new president was named. On August 15, 1943, the trustees appointed Hurst Robert Anderson, a college administrator with great experience. Within a few weeks, he presented a new budget and a detailed plan for Centenary's future. He would serve from 1943 to 1948.

The new president greets a newly arriving student in 1944.

Despite the war in Europe and the Pacific, Centenary students maintained a mostly normal college life. This campus fashion show took place in 1943.

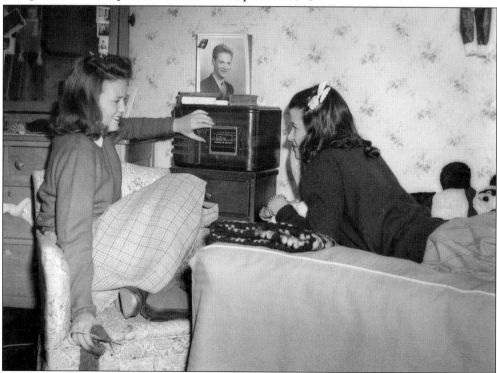

This photograph from the fall of 1943 shows students relaxing in their dorm room and listening to the radio.

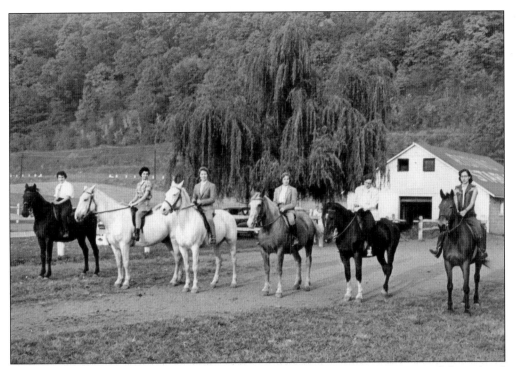

Physical education and outdoor activities remained an important part of the school curriculum. Riding on the numerous trails near campus was a favorite activity of many Centenary students.

Although the war was very far away, it was never far from the minds of the students. This group is making surgical dressings for the Red Cross. Students also raised money for air raid blackout curtains for the campus first aid station, which was available for both students and townspeople.

In September 1944, Centenary celebrated the 75th anniversary of the laying of the first cornerstone of the main building. President Anderson poses with Centenary alumni at the rededication ceremony.

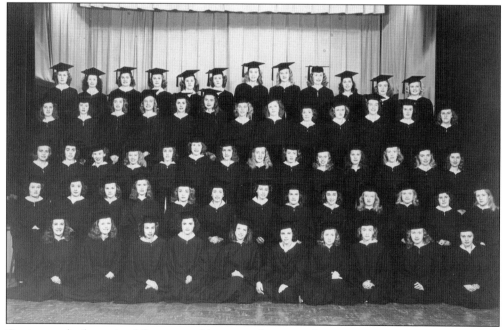

Centenary had survived fire, a world war, and a great depression. As World War II drew to a close, Centenary faced new challenges as American higher education would undergo profound changes in the decades ahead. The class of 1944 would face a very different world than had confronted the students who came before them.

Four

BUILDING YEARS
1945–1975

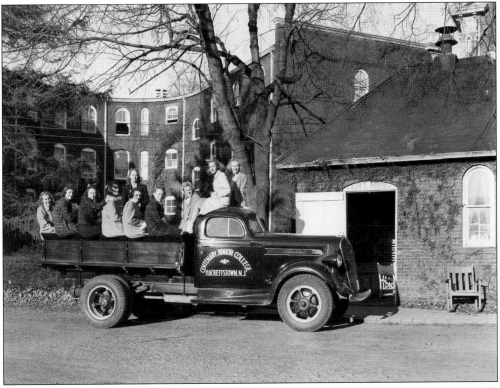

The "Butt House" was the only place on campus where the girls could smoke. It was a small, unheated building that once housed the college gas plant, which supplied gas for lighting rooms and for cooking. Later, when smoking was more generally allowed on campus, the building became the college paint shop. It was later torn down to make room for the West Dining Hall at the rear of the Edward W. Seay Administration Building. The vintage Studebaker college truck in the picture was used in off times to carry students to picnics and events away from the campus.

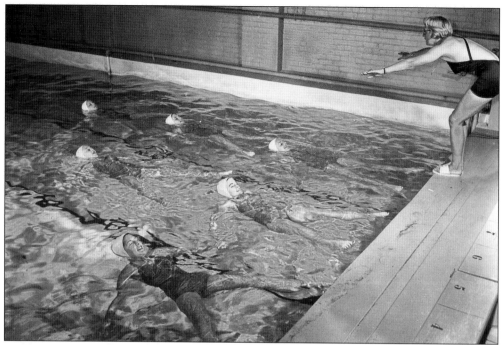

The original college swimming pool was located in what is now the basement of the Ferry Building. The pool stood alongside the gymnasium, which is now classroom space. A portion of the pool building and roof was later torn down.

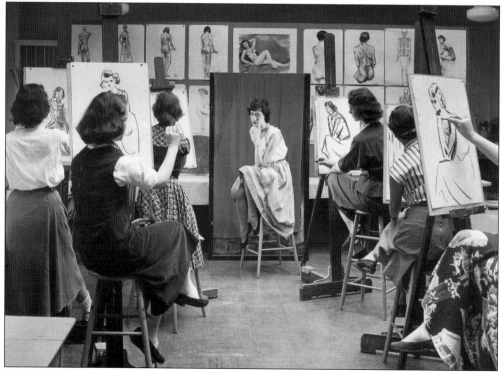

A student poses for an art class in Trevorrow Hall in 1946.

The first published history of Centenary was written in 1947 by Leila Roberta Custard, professor of social science. The publication of the book was a gift to the college by Marion L. Lewis, a college trustee and president of the Lewis Historical Publishing Company. It was to commemorate the 75th anniversary of the opening of the junior college, and proceeds from its sale were used to purchase books for the library. Pictured below are, from left to right, Dr. Victor G. Mills (dean of religion), Rev. Elmer E. Pearce (vice president of the board of trustees), Charles E. Lotte (president of the board), Marion Lewis and Dr. Custard (presenting the completed manuscript), and Hurst R. Anderson (president).

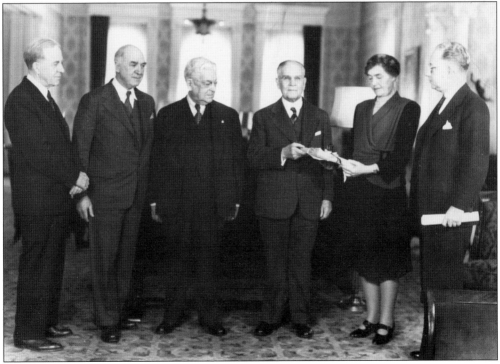

In 1948, President Anderson left the college to become president of Hamline University in Saint Paul, Minnesota. On September 1, 1948, Edward W. Seay became Centenary's eighth president. Called the "building president" by many, he embarked on an ambitious plan of construction of new dormitories, a student union, and a library. Existing structures would undergo extensive renovations and improvements. When President Seay took office, Centenary had 348 students. His goal was 650 students, which required the construction of new residence halls and a student union building.

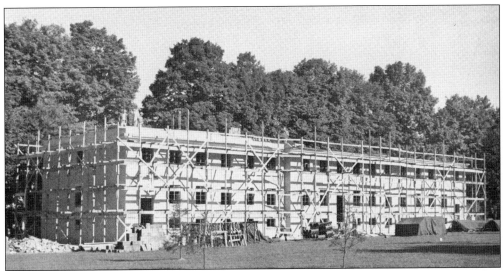

Lotte Hall dormitory nears completion in 1949. On November 5, 1949, former Centenary president Hurst Anderson returned to formally dedicate the new building to Charles Lotte, president of the board of trustees.

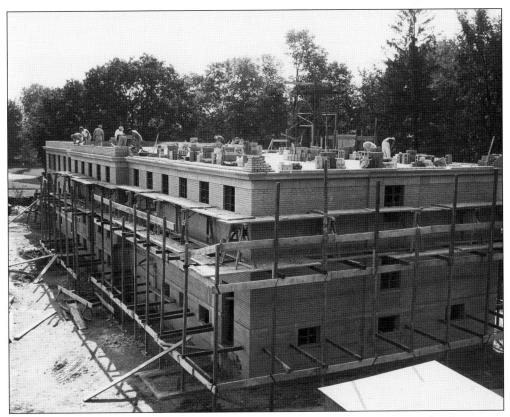

Van Winkle Hall, named for Charles A. Van Winkle, longtime secretary to the Centenary Board of Trustees, was dedicated on March 4, 1951. The basement provided studios and a small auditorium for the rapidly expanding radio department.

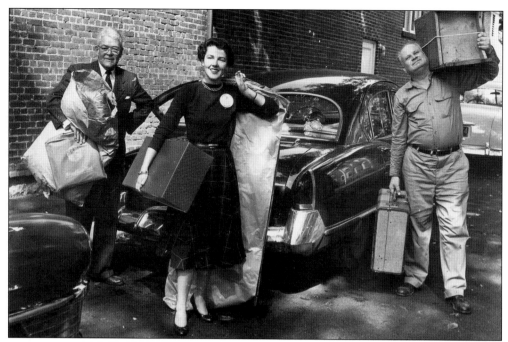

A new student arrives for the opening of the fall 1951 semester. Her father and a helpful maintenance man assist in moving her belongings.

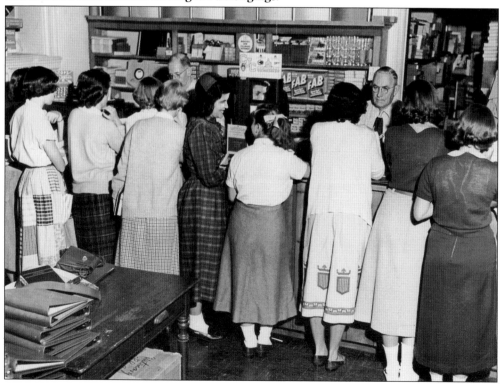

New students line up to purchase textbooks and necessities in the Centenary bookstore in 1951.

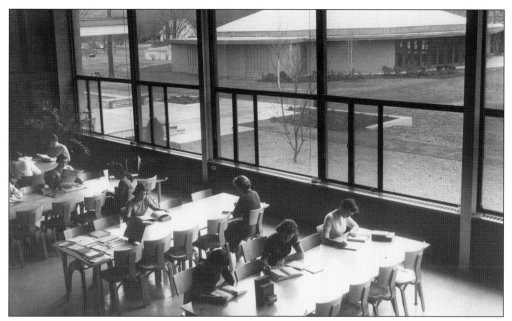

The Taylor Memorial Library and the Reeves student union building were constructed simultaneously starting in 1953. Their modern interior and exterior designs were meant to harmonize with each other. Both buildings received numerous architectural awards. Here, the Reeves building can be seen through the windows of the adjacent library.

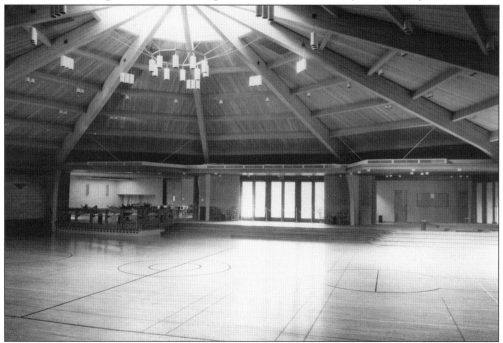

The Reeves building was named for John M. Reeves, a Centenary trustee. It was originally to be an all-purpose building, but soon a gym floor was added and it became the center of physical education and indoor sports at Centenary. Dances, commencements, and other events requiring a large indoor space were also held here.

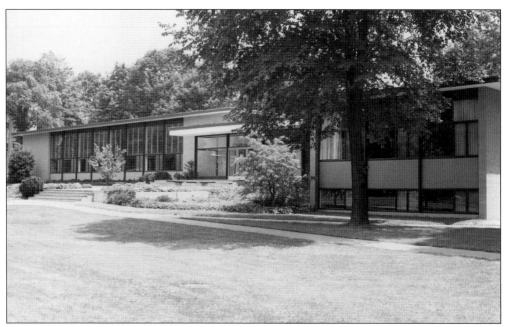

The library was named for William and May Andrus Taylor, class of 1890. It held 36,000 volumes and featured a current periodicals reading room, classrooms, and study space.

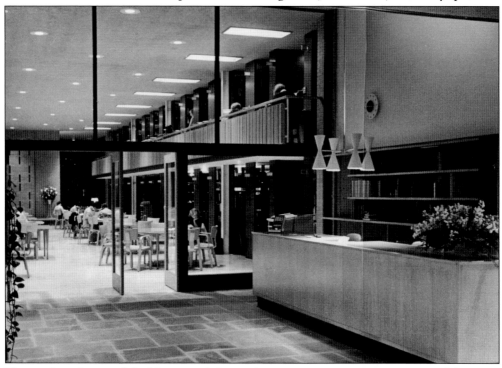

The modern design of the library and the stacks area were in contrast to some of the more traditional Centenary buildings. The clean and simple lines of the library furniture, most of which is still in use today, are much sought after by collectors. Today, the building has a pleasing "retro" feel.

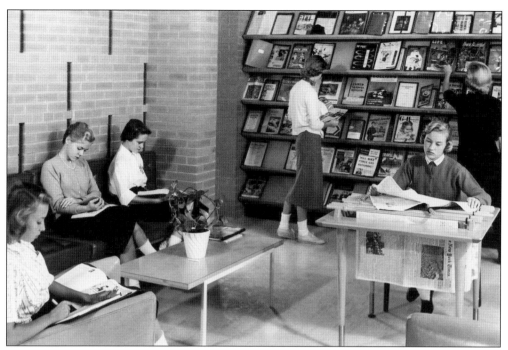

The library's periodicals room also featured large windows on one side that offered a sweeping view of the campus. This area has since been converted to offices for the Academic Success Center.

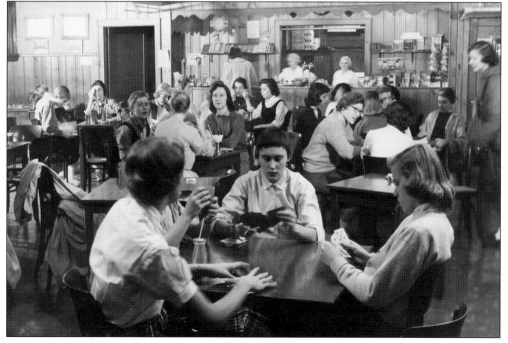

In the 1950s, the snack bar was an informal place to gather after class. It was located in the area of the present-day business office in the basement of the Edward W. Seay Administration Building.

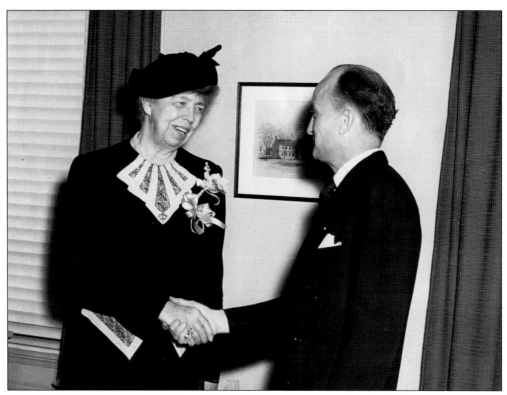

Former first lady Eleanor Roosevelt visited Centenary on November 9, 1951. Asked by a student reporter why she accepted Centenary's invitation, she said it came at a time when she was free, she had never been to this part of New Jersey, and she enjoyed addressing groups of young people, especially girls.

In 1951, Charles A. Van Winkle (center) presented Centenary with an original step of the south portico of the White House in Washington, DC, which was under renovation. Placed in the center of the quad, it served as a pedestal for a brass sundial given by the class of 1905 that stood for many years on the front lawn of the campus. No one seems to know how Van Winkle was able to procure the massive stone step. He stands with Elmer E. Pearce (left), vice president of the board of trustees, and President Seay (right).

Construction began on a new dormitory, Brotherton Hall, in 1955. DuBois Hall, located on the corner of First Avenue and Moore Street, had to be picked up and moved across campus to make room for the new building. The three new dormitories—Lotte, Van Winkle, and Brotherton—each housed approximately 64 students.

Mr. and Mrs. Fred J. Brotherton pose on the front entrance of the new dormitory in 1956. Fred Brotherton was a Centenary trustee and owned a contracting business, which built many of the new structures on campus, including the one that bears his name.

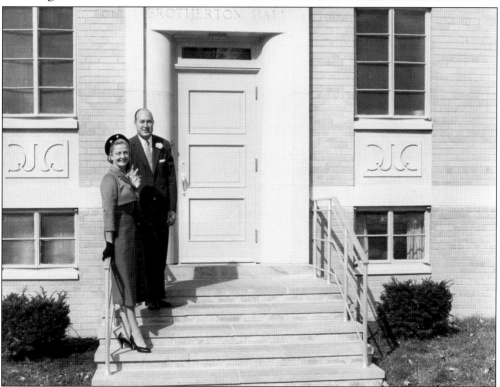

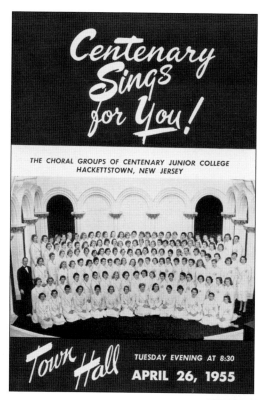

The Centenary Singers were a choral group of 125 students and a traveling concert group of 45 students. They performed at Carnegie Hall and Town Hall in New York City to rave reviews and were featured on a coast-to-coast radio program on the Mutual Broadcasting System. One music reviewer said that "[they] are professional-sounding, yet possess the joyfulness and light-heartedness of youth, which is often lost in professional groups."

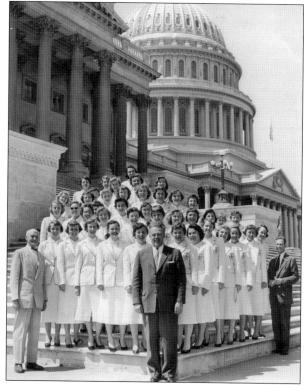

The Centenary Singers pose on the steps of the US Capitol after a concert in Washington, DC, in 1955. In 1964, the Singers made two appearances at the New York World's Fair.

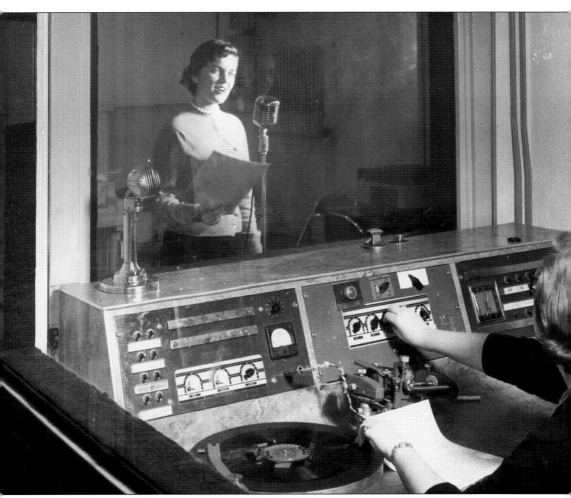

In August 1958, Centenary was granted an FM broadcasting license by the Federal Communications Commission. The *Atlantic City Press* donated a complete broadcast studio and FM transmitter to the college. The studio equipment was transported to Hackettstown and installed in the basement of Van Winkle Hall. A site was procured in the Oak Hill section of nearby Independence Township, where the transmitter was reassembled and a 100-foot antenna was erected. The college requested the letters "NTI" in the station's call letters, which are the initials of a Latin phrase that translates as "Know Thyself"—a motto, the press release said, "which expresses the educational aim of the programs to be presented over the new broadcasting facility."

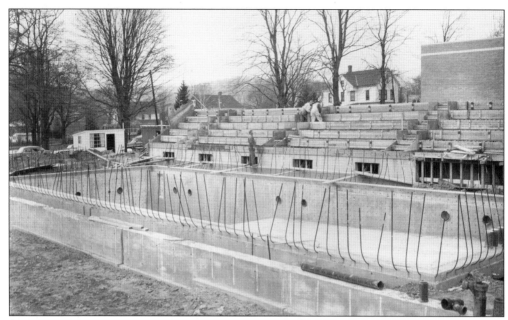

Construction began on the new swimming pool in 1960. The pool was 75 feet long, and the bleachers seated 300 people. The new structure would become a wing of the Reeves building. Showers and locker rooms would be added next to the natatorium, and a new dance studio (now the Fitness Center) would be built on the floor above.

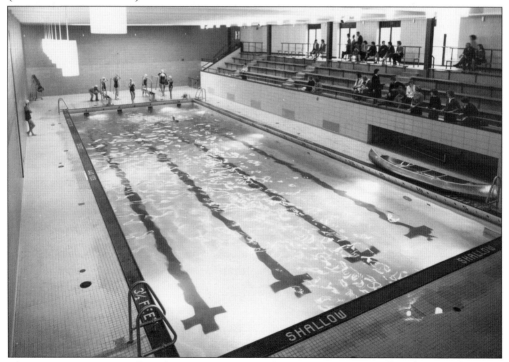

The Ferry natatorium officially opened with a "splash party" on December 4, 1961. The total cost was $413,500. Joseph R. Ferry, grandson of George J. Ferry, attended the ceremony and presented the keys to the building to President Seay.

On February 20, 1962, astronaut John Glenn orbited the earth three times in *Friendship 7* during Project Mercury. The nursery school students at Centenary decided to design their own space mission, fashioning helmets from papier-mâché and a spaceship made from aluminum foil, cardboard, tin cans, thread spools, and dowels.

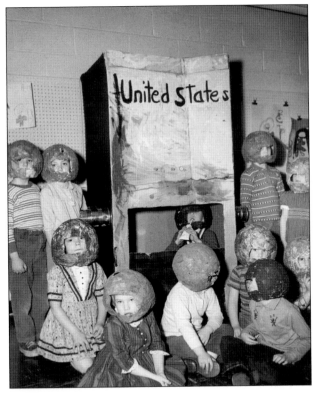

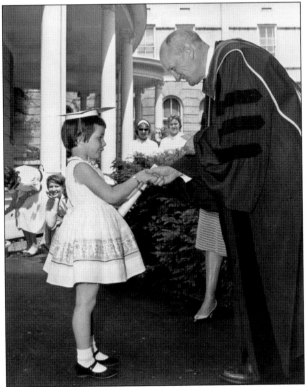

Every spring, President Seay would don his academic regalia and preside over the Centenary nursery school graduation. Here, he is presenting a diploma to Bonnie Jean Young on May 24, 1962, on the steps of South Hall.

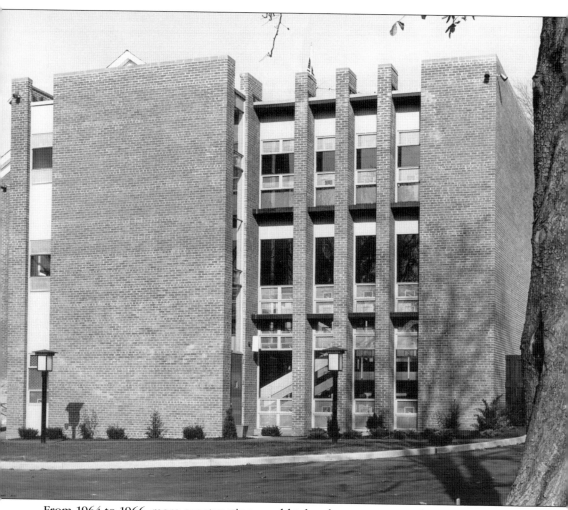

From 1964 to 1966, more construction would take place on campus than at any other time in the college's history. When the Reeves building and natatorium were completed, the Ferry Building was torn down to the exterior walls and completely rebuilt inside to create a new music and arts center. The gym and the old pool were replaced by two additional floors of classrooms, music practice rooms, an art gallery, and a recital hall. On the North Hall and South Hall dorms, hallways were built to connect them with the main building. A new dormitory, Anderson Hall, was added. In 1966, the Seay student union was attached to the back of the Edward W. Seay Administration Building and included a sunken lounge, post office, bookstore, grill, and additional dining space. The photograph shows the exterior of the addition to the Ferry Building.

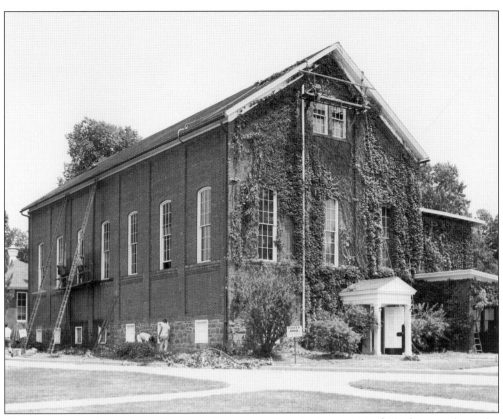

The exterior of the Ferry Building is pictured as it looked in July 1963 before work on the new addition had begun. Workers are cleaning the brick and removing vines from the sides of the building.

The steel skeleton of the $510,000 Ferry Building addition takes shape in October 1963. In 1964, the new music and arts building was dedicated to George J. Ferry, trustee for 16 years and graduate of the class of 1907. It would officially open in 1965.

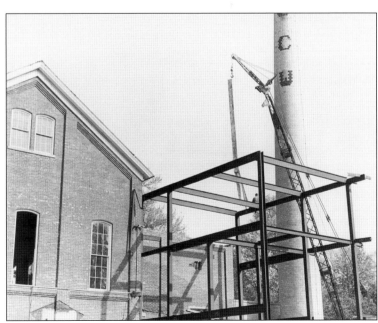

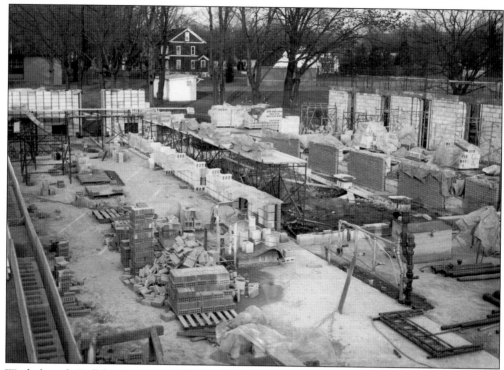

Washabaugh Hall begins to rise from its new foundation in March 1962. The exterior was designed to blend in with the architecture of the library and the Reeves building. The cost was $485,000, and it would house 75 students.

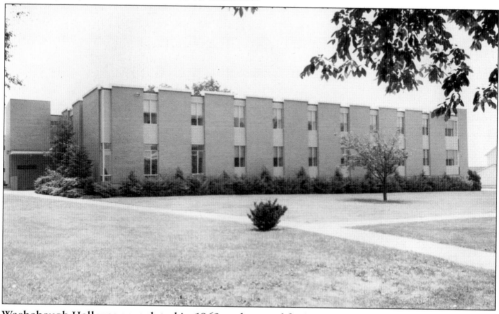

Washabaugh Hall was completed in 1963 and named for Dr. J. Edgar Washabaugh, president of the board of trustees since 1954 and a college trustee since 1929. To complete the interior decorating, the first floor lounge was painted and new drapes were installed. Helen Seay, the wife of the president, supervised the work.

Anderson Hall, named in honor of Centenary's seventh president, was completed in 1965. By this time, enrollment had risen to the point where students were forced to stay in nearby private homes. The new dorm housed 80 residents and allowed all students to live on campus.

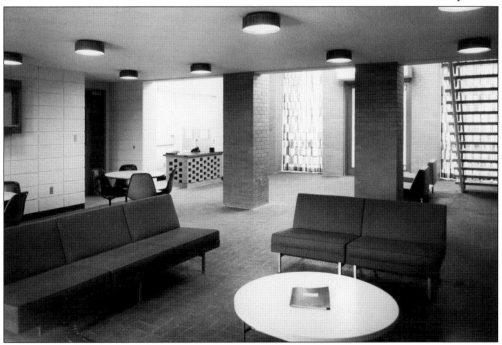

The student lounge in Anderson Hall is pictured as it looked in 1965. Since the new building stood on land used as athletic fields, new playing fields and tennis courts were constructed on the Fifth Avenue end of the campus.

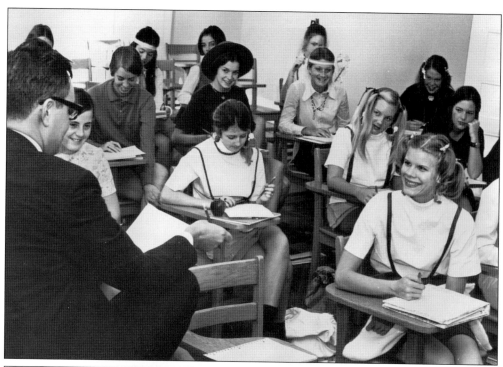

Professor of English Harry
Strickhausen delights an
English Composition class
in October 1969. He retired
in 1999 after 30 years in the
classroom.

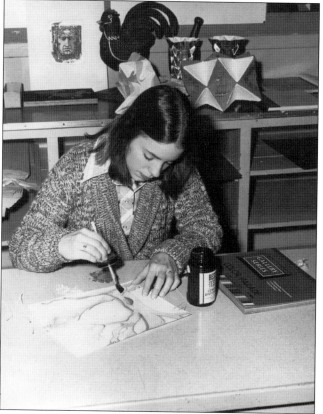

A student puts the finishing
touches on a sketch in
Prof. Richard Wood's two-
dimensional design class.
Art and design classes have
remained very popular at
Centenary, even into the
digital age.

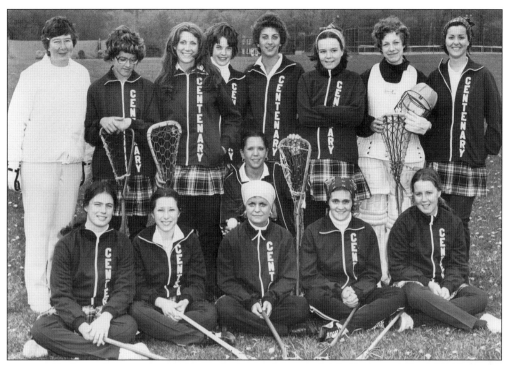

In the 1970s, athletics remained a very important part of the Centenary experience. Popular sports were basketball, tennis, fencing, volleyball, swimming, and lacrosse.

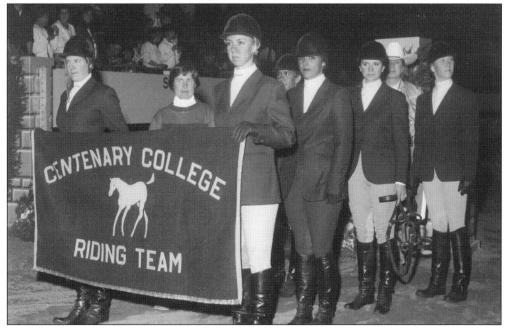

Riding became a team sport when Centenary joined the Intercollegiate Horse Show Association. Students trained at the Jersey Training Farm on Schooley's Mountain. Starting with a handful of committed student riders, the program grew to be one of Centenary's most popular academic programs.

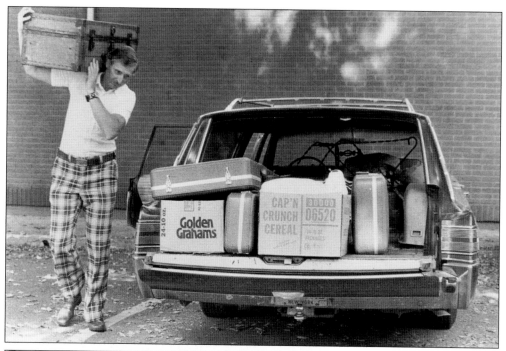

Move-in day has become a tradition at Centenary—faculty, staff, administrators, and students all pitch in to get newly arriving freshmen settled in. But in the fall of 1975, this father was on his own as he unloads the family station wagon.

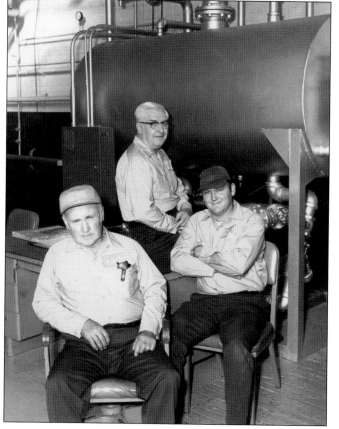

The unsung heroes of Centenary are the men and women who clean the buildings and grounds, serve the food, provide security, repair what needs fixing, and furnish heat and light. These three men in charge of the boiler room, proudly wearing their CCW work uniforms, pose for a picture in December 1975.

Five

DAYS OF CHANGE
1976–1987

In September 1975, shortly after the fall semester began, President Seay announced that he would retire, effective July 1, 1976. He had served the college well for 28 years. Renowned New Jersey historian John T. Cunningham paid tribute to his friend upon his retirement: "I have long known the bell in the tower is tuned to the key of Seay—as is all of the life and spirit of Centenary College. Few college presidents ever have left a greater personal imprint on a campus than Ed Seay. . . . Centenary College has been his life and his love, his reason for being." The main building was renamed the Edward W. Seay Administration Building in his honor in 1959.

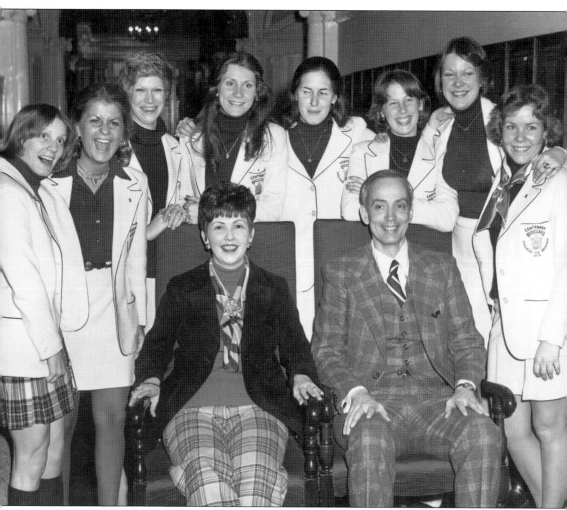

In April 1976, Dr. Charles Dick, former vice president of the Cornell University Medical Center in New York City, became Centenary's ninth president. This photograph of Dr. Dick and his wife, Barbara, and students in their white Centenary blazers was taken at a special convocation on March 9, 1976, to announce Dr. Dick's presidency. He inherited a college experiencing a drastic decline in enrollment and badly in debt, partly due to a nationwide economic recession. Centenary was in real danger of closing if new students and revenue could not be found. At his inauguration on October 23, 1976, President Dick unveiled a comprehensive self-evaluation plan to "critically examine every aspect of our academic mission." He presented a 10-year plan to move the college forward. One part discussed the possibility of Centenary becoming a coed institution once again—a move strenuously opposed by President Seay. Dr. Dick was a popular president, praised for getting to know everyone on campus personally. He and his wife enjoyed entertaining and held many events at the President's House. He was also frequently seen at college athletic events.

In the fall of 1973, an associate's degree in equine studies was introduced. The Centenary Equestrian Center was located at Finisterre Farm in nearby Washington Township. In 1977, the director of the program was Ralph Gillis, a lifetime horseman and instructor. In May 1978, the riding team qualified for the National Intercollegiate Horse Show being held in Tennessee. Gillis attended a preshow banquet, returned to his hotel room, and suffered a fatal heart attack. The next day, the shocked and devastated team debated whether they should go home. Instead, they decided to compete in Gillis's honor. That day the team gave him the highest tribute—they won the national championship for the second consecutive year.

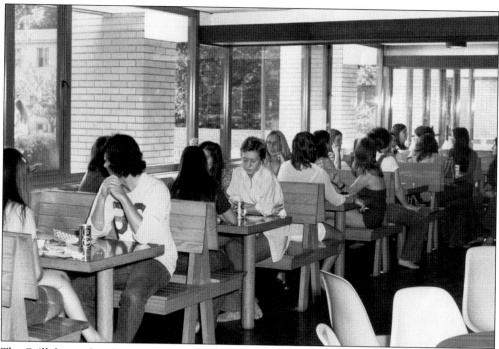

The Grill, located at the rear entrance of the Edward W. Seay Administration Building, was the place to go to relax between classes or grab a quick lunch. At one time, it was also a pub that served wine and beer, until the national drinking age was changed to 21 years in 1984.

In the fall of 1986, a contest was held to rename the Grill. The winning entry was "Tillie's," after the young woman who was murdered on the Centenary campus in 1886. The red neon sign (incorrectly spelled "Tilly's") glowed in the window and out across the quad until one day in the 1990s it mysteriously disappeared. It was never found.

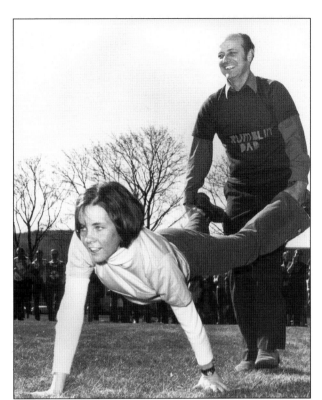

Dad's Day was a fun springtime tradition in which fathers and daughters teamed up and competed against rival sororities. Feats of skill included the wheelbarrow relay and sack races (shown here), the three-legged race, egg toss, and tug-of-war.

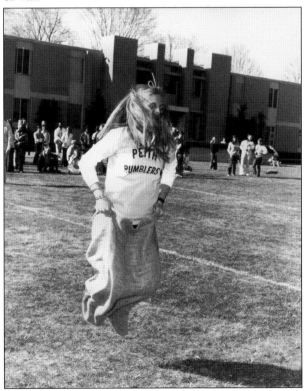

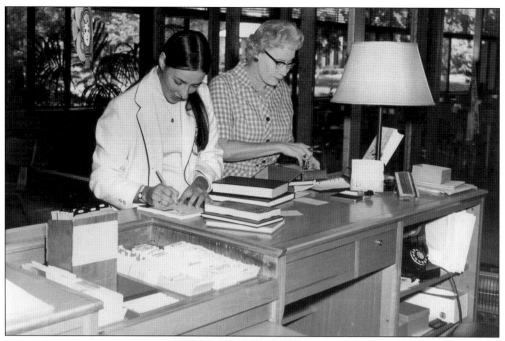

A student assists librarian Ruth Scarborough in checking out books in Taylor library. Scarborough served as the head librarian from 1946 to 1982.

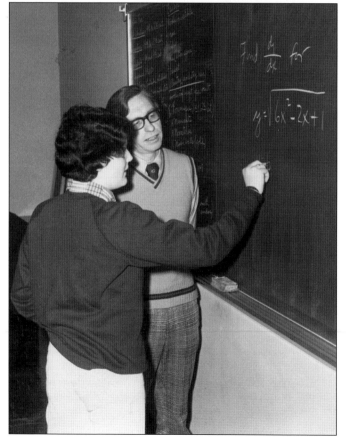

Sarah Smith, class of 1977, works through a problem on the chalkboard under the watchful eye of professor of mathematics Henry Deibel in his Analytical Geometry and Calculus II class in 1975.

In the 1970s, a growing number of students indicated that they would stay at Centenary for two more years if a bachelor's degree was offered. In the fall of 1973, President Seay announced that a four-year degree in general studies would be offered. Bachelor's programs would soon be added in business administration, journalism, equine studies, fashion merchandising, and recreation management. All students would first earn an associate degree before transferring to the new bachelor's programs. The college curriculum was moving away from vocational-oriented programs, such as secretarial science and home economics, toward more career-oriented majors.

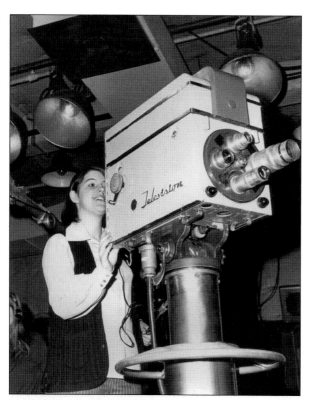

In the 1970s, a closed-circuit television studio was built in the basement of Van Winkle Hall, next to the WNTI radio studios. Students also had the opportunity to study television broadcasting in the RCA and Sylvania GTE studios in nearby New York City.

The first mainframe computers arrived on campus in the 1970s, followed by desktops in the early 1980s. This kindergarten student in the Centenary Children's Center was probably far ahead of most college students and faculty at the time.

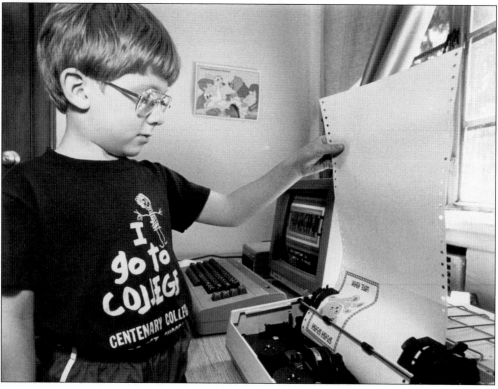

The Centenary Equestrian Center at Filly Hill, located a few miles from the main campus, was officially dedicated in 1982. Program director Jere Gilbert said, "The new facility is a reflection of New Jersey's prominence in the thriving horse industry nation-wide." Since that time, Centenary's program has gained national recognition and remains one of the most outstanding equestrian programs in the country.

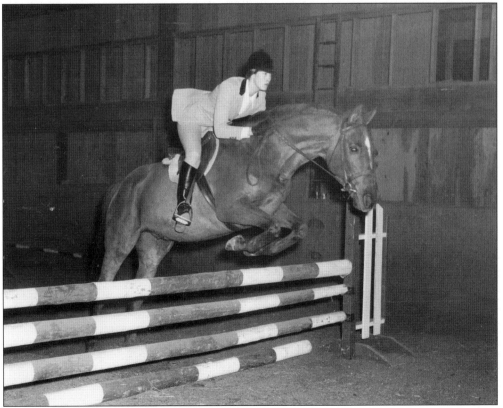

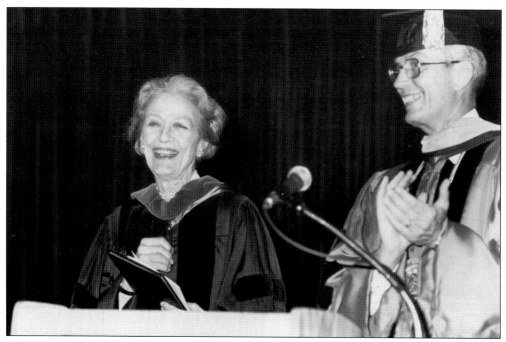

At the May 1982 commencement, 72-year-old Millicent Fenwick, the colorful New Jersey congresswoman and candidate for the US Senate, received an honorary doctorate. In her speech to the students, she said: "Getting married and raising a family is the most important thing you can do. There will be a time after your children are raised to enter the workforce and make your mark." Many of the all-female graduates in the audience, who were eager to begin their careers, found her remarks to be a little out of date.

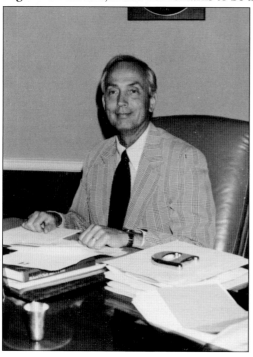

By the end of 1983, Dr. Dick's health was declining. During this time, however, the college's debt continued to grow. A dwindling full-time student population and financial hardships again put Centenary's future in doubt. The May 8, 1984, edition of the *Quill*, the student newspaper, announced that after eight years, President Dick was resigning due to health reasons. His presidency saw the addition of four-year programs in business, equine studies, and fashion. An evening division, which allowed men to attend Centenary as well as women, grew to 800 students. His 10-year master plan contained improvements in curriculum, facilities, faculty governance, and student affairs. Kenneth Powell, the vice president for academic affairs, was named acting president, and the search began immediately for a new president.

The November 1984 issue of *The Centenarian* announced the appointment of Dr. Stephanie Mitchell Bennett as Centenary's 10th president—the first woman to hold the office in the college's 118-year history.

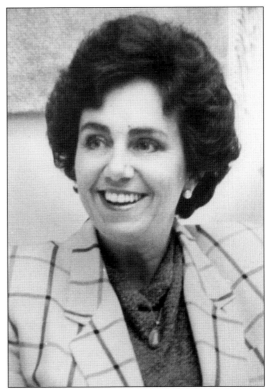

Sadly, in the same issue, *The Centenarian* also announced the passing of Ernest Rockwell Dalton, longtime faculty member and administrator who began his career at Centenary in 1947 and served three presidents, retiring in 1980. Dr. Dalton wrote a massive manuscript on the history of the college that unfortunately he did not live to complete. Although unpublished, it remains the most authoritative and detailed source on the college's history.

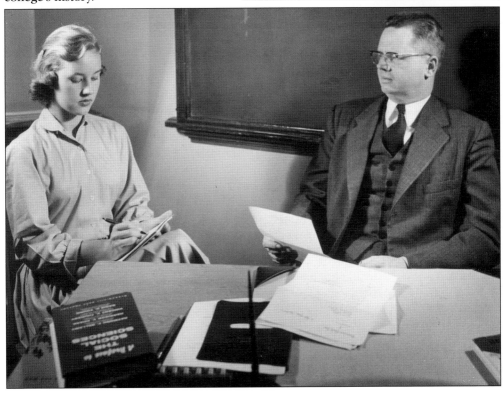

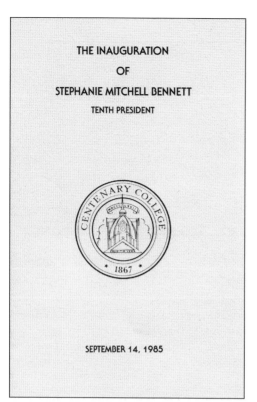

THE INAUGURATION

OF

STEPHANIE MITCHELL BENNETT

TENTH PRESIDENT

SEPTEMBER 14, 1985

Dr. Stephanie M. Bennett was sworn in on October 14, 1985. Her first priority was to place Centenary back on a firm financial footing. Sweeping academic changes were made, including the elimination of 95 courses. A new liberal arts core and curriculum were implemented, which included new majors in English and history. Career and degree programs and expanded career adult programs were added to attract new students.

As a women's college, Centenary's enrollment approached 700 students in 1970. By 1975, it had fallen to 430 full-time students, putting the college's future in danger. By 1982, enrollment had rebounded to nearly 700 but again began a slow and steady decline. By 1987, college officials were seriously discussing a return to coeducation. With the expanding population of northwestern New Jersey and the fact that Centenary was the only four-year New Jersey college in the area, President Bennett and the trustees were confident that going coed would be the right choice.

92

On April 13, 1988, the Centenary College trustees announced that they had voted unanimously to admit men to the college for the first time since 1909. The first males would be commuter students; housing would be provided the following year. Not all of the female students were enthusiastic about the change. One student lamented: "We dress very casual here. A lot of people were saying, 'Now I have to dress up, there's going to be men here.' " Another student said that she transferred to Centenary from a coed college for a better education, "where there wouldn't be distractions. . . . Centenary is unique in its own way, and now it seems the uniqueness is leaving."

In September 1988, eight men joined 490 women for the opening of Centenary's 1988 fall semester. One year later, 40 men were enrolled, living on all-male floors in Van Winkle Hall. The transition went very smoothly, and the women quickly adapted to the change. President Bennett said that the college hoped to recruit more male students in the following years and establish athletic teams in basketball, swimming, cross-country, track, and tennis. One thing, however, was overlooked—more men's bathrooms needed to be added around campus.

This image was part of a promotional poster for transfer students in 1989. Although it shows male and female students comfortably relaxing together, some noted that there was a period of adjustment on campus before both sexes felt comfortable in more informal social settings.

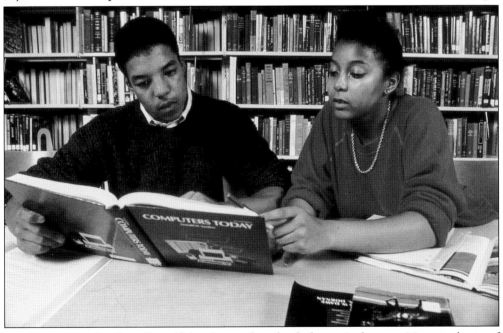

Centenary was further diversifying its student body by actively recruiting students of color. Traditionally, very few African American students attended the college over the years. A conscious effort was undertaken to attract and enroll students from all ethnic and socioeconomic backgrounds in New Jersey as the 1980s came to a close.

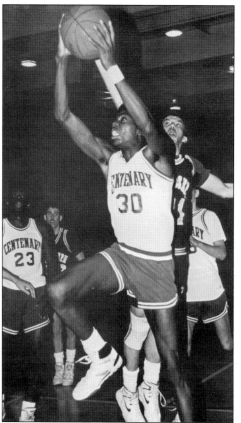

In 1989, Cardy Gemma was hired as director of athletics to create a men's sports program. The men's basketball team was formed in 1989 with Gemma serving as head coach until 1994. A men's soccer team was added in 1990. In 1997, the basketball team was the first Centenary athletic team to be accepted into the NCAA, Division III. After Centenary joined, home games had to be played at Hackettstown High School, as the court dimensions in Reeves gymnasium were too small.

Six

TRANSFORMATION
1988–2012

The story of Centenary College has been one of transformation and change. As the new century neared, the pace of change accelerated and the challenges became ever greater. As it was from the beginning, the college was prepared to take bold steps to serve a new generation of students. Computers and the Internet had profoundly changed higher education. A growing number of adults sought programs to accommodate their busy lives. Many now desired further education beyond the bachelor's degree. College campuses became more diverse and their emphasis more global. New courses and new majors would need to be created. Facilities would need to be improved, renovated, and upgraded. It would be a challenging time for the entire Centenary community, but an exciting one as well.

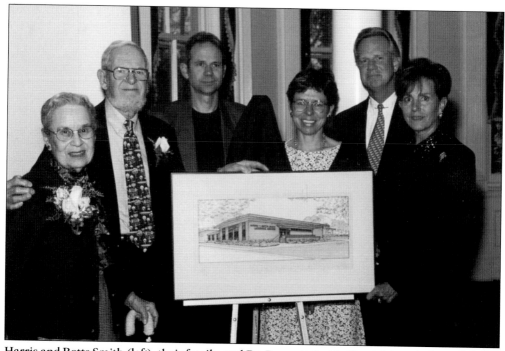

Harris and Betts Smith (left), their family, and Dr. Bennett-Smith (far right) with the architect's drawing of a new campus building to be named in their honor. Harris Smith's great-grandfather, Cornelius Walsh, was elected the first president of the board of trustees in 1867. Harris served 24 years as a trustee and board president, retiring in 2006. He and Betts have given generously to Centenary College.

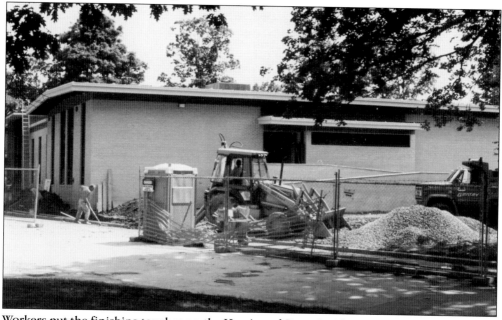

Workers put the finishing touches on the Harris and Betts Smith Learning Center in 1996. It was the first building project on the campus since Anderson Hall was built in 1967. It contains four classrooms and also houses the Academic Success Center.

In June 1999, President Bennett-Smith announced the beginning of "The Capital Campaign for Centenary College." The $15.3-million campaign would provide funds to begin two major projects: the expansion of the Equestrian Center and the restoration of the exterior of the Edward W. Seay Administration Building. "The dome will shine once again," Dr. Bennett-Smith said.

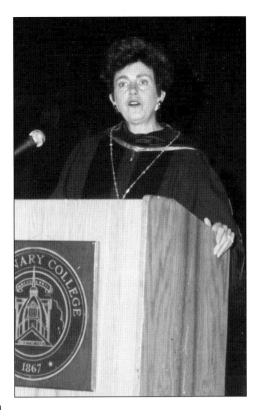

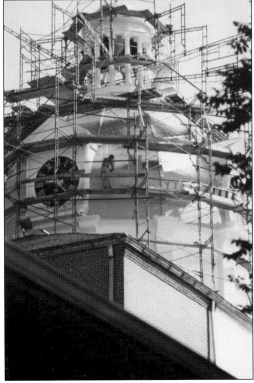

By the winter of 2000, a total of $13 million in gifts and pledges were received. Work began immediately on the Seay building, starting at the very top— with the restoration of the flagpole, bell tower, and dome.

Both exterior and interior work needed to be done. Classrooms were repainted and fitted with acoustic ceiling tiles. Original slate chalkboards were replaced with white boards, and badly needed new classroom furniture was added.

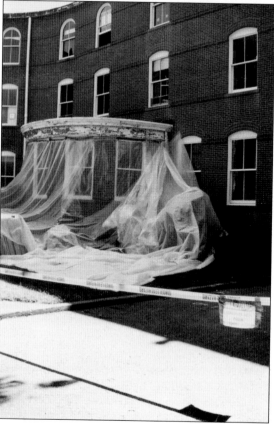

South Hall dormitory (now Smith Hall) was left vacant for many years and required a complete face-lift, inside and out. Damaged wood and lead paint had to be removed. The dormitory was transformed into a living, working, and studying environment for Centenary's growing population of international students.

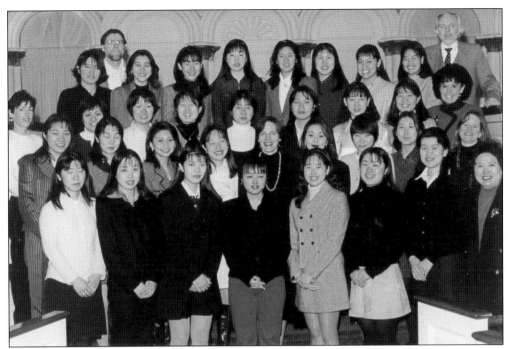

Centenary's first global initiative was the Japan Institute. It began with 40 students from Obirin College, near Tokyo. Today, students from 20 countries are on campus. American students also have the opportunity to study abroad as exchange students in China, Japan, Northern Ireland, and the United Kingdom.

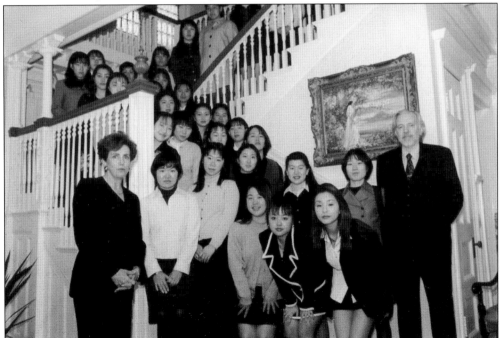

A group of Obirin College students pose on the stairway in the President's House with Dr. Bennett-Smith and Dr. John Shayner, director of international studies, in 2000.

The steel structure of the new United States Equestrian Team Arena at the Centenary Equestrian Center begins to rise in the spring of 2000.

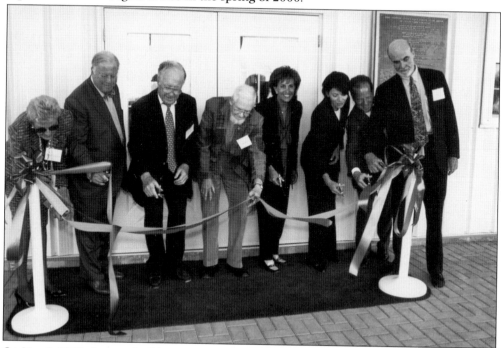

On May 9, 2001, the new building was dedicated. The 30,500-square-foot structure contains a 100-by-220-foot indoor riding arena, spectator seating, classrooms, and faculty offices. It was named in honor of John H. Fritz, a Centenary trustee who was also a member of the United States Equestrian Team and cofounder of the Intercollegiate Horse Show Association.

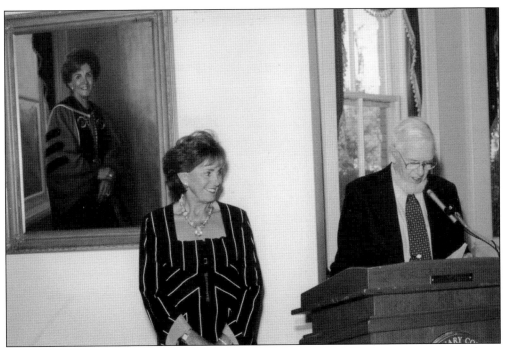

On February 14, 2001, Dr. Stephanie Bennett-Smith announced that she was stepping down after 17 years. Her greatest accomplishment was putting the college back on a firm financial footing after many years of debt. "Dr. Bennett-Smith's years at the school were a true turning point in the history of Centenary," said Harris Smith, chair of the board of trustees.

Dr. Bennett-Smith spends some time with professor emeritus Harry Strickhausen at the dedication of Bennett-Smith Hall dormitory in 2003.

Kenneth L. Hoyt was named Centenary's 11th president on February 14, 2001. He had formerly served as president of the Ohio Foundation of Independent Colleges in Columbus, Ohio, for 16 years. Harris Smith, trustees chair, said of Hoyt's appointment, "Our vision for Centenary College is a bold one; we will be fortunate to have Dr. Hoyt at the helm as that vision is fulfilled over the next decade."

President Hoyt accepts the presidential medallion from Harris Smith at the inauguration ceremony on October 18, 2002.

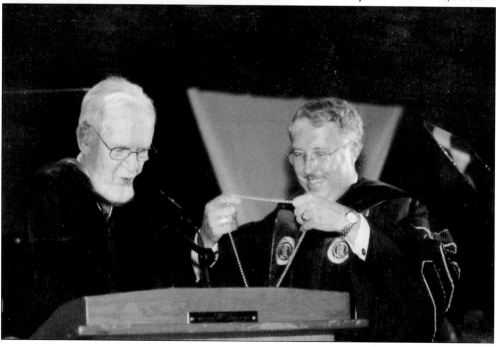

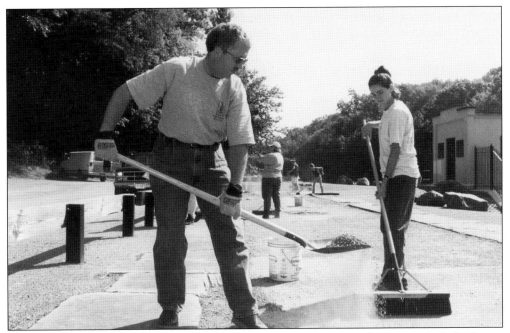

President Hoyt mans a shovel for Centenary's annual Community Plunge, in which freshmen students volunteer during the first week of the fall semester to participate in activities to help out local charitable organizations. Students here are helping to clean and landscape the visitor's area in nearby Saxton Falls State Park.

Dr. Hoyt could rightly be called the "second building president." Like President Seay, a great number of new buildings and renovations appeared on campus during the Hoyt administration. At this alumni gathering, he discusses the master plan for future expansion at Centenary.

On April 25, 2003, the new Littell Technology Center was dedicated in honor of Robert E. Littell and Virginia N. Littell. Robert Littell (third from left) was the longest serving legislator in New Jersey's history. He was appointed to the Centenary Board of Trustees in 1996. "Ginnie" Littell (second from left) has been widely honored for her outstanding civic leadership in northwestern New Jersey. President Hoyt is on the left; on the right is New Jersey state senator (now US congressman) Leonard Lance.

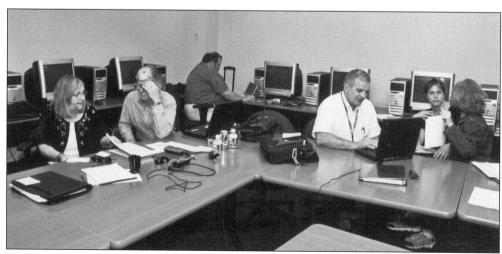

The Robert E. and Virginia N. Littell Technology Center contains four "smart" classrooms, each of which serves as computer lab or seminar hall. Six offices for faculty and staff are also in the building. The facility was designed to support a future second-floor addition.

Prof. Carl Wallnau (right) has worked tirelessly on behalf of the arts and the theater for almost three decades. His efforts have brought outstanding actors, playwrights, and musicians to Centenary. He is also an accomplished actor himself, performing in shows around the country. Here, he accepts a donation from Michael Halpin (left), president and CEO of Hackettstown's Skylands Bank.

Prof. Charles Frederickson taught psychology at Centenary for 29 years, retiring in 2010. Students remember him as a master teacher and for his enormous influence on their lives and careers.

The annual May commencement has always been a time of joy and celebration on campus. In past years, it was held in the quad, or in the old Reeves gymnasium during inclement weather. But for 10 years, from 1985 to 1995, ceremonies were all held indoors. In 1996, students petitioned the administration to again hold it outside. It is now held each year on the front lawn.

What would Centenary be without its master chef? Linda Gonia always goes above and beyond "cafeteria food" in feeding students and staff every day and preparing meals for special campus events. She also traveled to Louisiana five times to provide three meals a day to hundreds of Centenary students who journeyed yearly to New Orleans after Hurricane Katrina to help with rebuilding efforts.

Bennett-Smith Hall was dedicated on October 16, 2003, becoming the first new dormitory on the Centenary campus since 1967. The three-story residence hall houses 124 students and contains 31 individual apartments for upperclassmen.

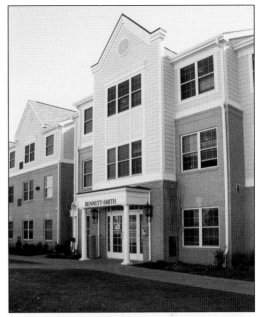

Founders Hall was opened in 2006. The name honors 10 prominent citizens of Hackettstown who stepped forward in 1867, the year of Centenary's founding, to donate $10,000 and 10 acres to ensure that the new college would be built in Hackettstown. Architecturally, it is nearly identical to the adjacent Bennett-Smith Hall, and its completion allowed Centenary to keep pace with its dramatic rise in student enrollment.

After Centenary joined the NCAA, it was obvious that a new and larger athletic center was needed. In May 2006, demolition began on the old Reeves building. A spectacular new gym would rise in its place. The dance studio would be converted to a fitness center, and the original swimming pool would remain. A 5,000-square-foot wrestling center was added in 2010.

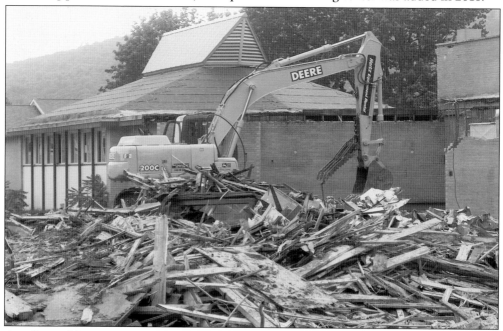

Goodbye, old Reeves! For many, the building of a new gym was bittersweet—a necessary improvement but a loss of tradition. The elegant design of the old building and the thousands of games, dances, and commencement events held there over the years would become just fond memories.

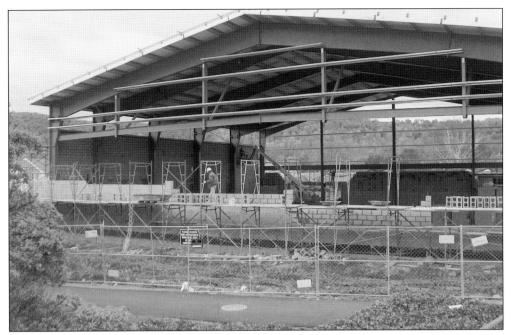

The structure of the new gym begins to rise in the fall of 2006. The $5-million expansion and renovation was completed in March 2007. The athletic facility was expanded to 30,000 square feet, including a 1,200-seat gymnasium, two full-sized multipurpose courts, indoor batting cages, new athletic staff offices, and athletic training facilities.

The new gymnasium has become a center of activity on the Centenary campus. Due to the large number of students, a January commencement ceremony was added in 2006, which takes place in the Reeves center.

In 2006, Centenary launched a $33.6-million capital campaign, which was given a significant start with an $8-million donation from David and Carol Lackland. Carol was a 1954 Centenary graduate who went on to a career at CBS television in New York City. David, the founder of Lackland Self Storage Company and a Centenary trustee, said they wanted to support "an educational institution that shows so much promise."

The Maintenance Building was erected in 1964 and housed the Facilities Department office and a carpentry and repair shop as well as a common campus storage area. It was demolished to make way for the new Lackland Center.

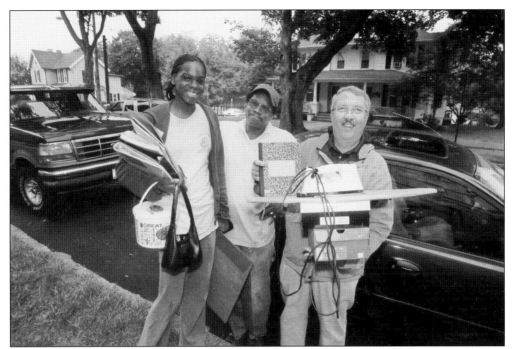

On August 7, 2008, President Hoyt announced that he would be leaving Centenary, effective in December of that year. He told a group of faculty and staff assembled in the Whitney Chapel, "I have enjoyed my Centenary experience, especially our students, and working with a dynamic board, faculty, staff and alumni, and I am proud of the college's reputation. . . . I've concluded that I have accomplished for Centenary what I came to do."

During Dr. Hoyt's tenure, Centenary doubled its enrollment to more than 3,100 students. A wireless laptop initiative was launched, and four new buildings were erected. One month after President Hoyt's announcement, construction began on the David and Carol Lackland Center, the largest building project undertaken by Centenary College in its 143-year history.

Men's and women's athletics have continued to be an important part of student life at Centenary. Men's teams include baseball, basketball, cross-country, golf, lacrosse, wrestling, and soccer.

Women athletes at Centenary compete in basketball, cross-country, lacrosse, soccer, softball, and volleyball.

Academic Foundations at Centenary (AFC) is a yearlong program designed to bridge the transition from high school to college for new students. Professors offer special classes with interesting and timely topics designed to equip freshmen with the tools they need to succeed. Prof. Norman Cetuk leads a class of first-year criminal justice students in a seminar designed for their major.

One of the goals of Academic Foundations at Centenary is to introduce students to veteran professors who they will encounter as they progress to upper-level courses in their major. Associate professor of English John Holt, with more than 20 years in the classroom at Centenary, leads a group of freshmen as they explore the joys of literature and poetry.

With the Maintenance Building gone in the fall of 2008, the foundation of the Lackland Center is ready to be constructed.

A large crane places the first steel pillars of the new building into place.

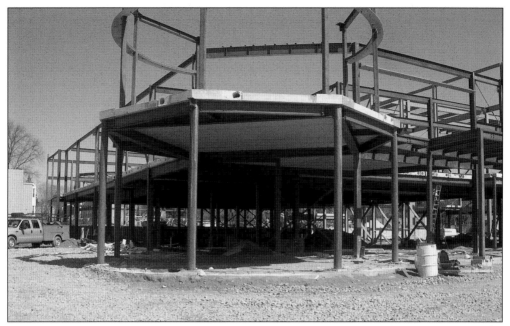

The steel frame of the Lackland Center begins to take form in the early spring of 2009. Work proceeded slowly but steadily throughout a cold New Jersey winter.

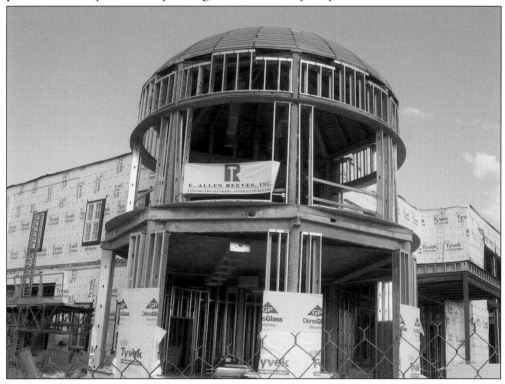

As the weather warmed, the pace of construction accelerated. In early summer, the administration offered hard-hat tours to interested faculty and staff for an inside look at the new Lackland Center.

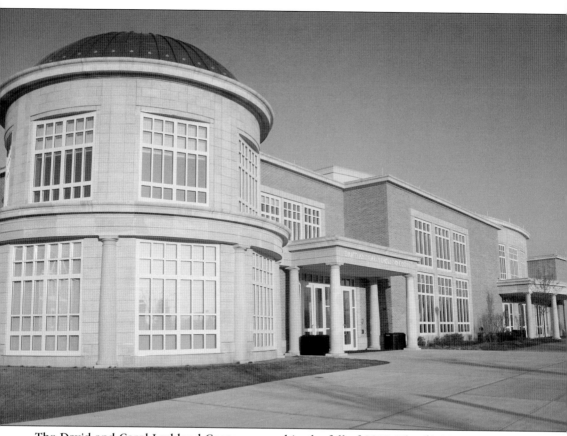

The David and Carol Lackland Center opened in the fall of 2010. The 68,000-square-foot, state-of-the-art building is home to Centenary Stage Company, WNTI 91.9 FM radio station, and CCTV Channel 23 television station. It also houses the 485-seat Sitnik Theater, the Edith Bolte Kutz '42 Theater (a black-box theater), a 400-seat dining hall, a 55-seat café, and a dance studio as well as classrooms, offices, meeting spaces, and lounges. In 2012, the building was highlighted in *American School and University* magazine in the Outstanding Design Category. On September 24, 2010, award-winning singer and actress Maureen McGovern performed at the opening gala. Since then, scores of nationally known musicians, actors, playwrights, and dancers have performed in the theater. It has become a focal point for the performing arts in northwestern New Jersey.

The Young Performers Workshop at Centenary serves as a setting for cultivating young theater performers between the ages of 8 and 18. The program is one of only a handful in the nation that offers both formal training and production experience for young people. Students study technique in acting, voice, and dance with a staff of theater professionals.

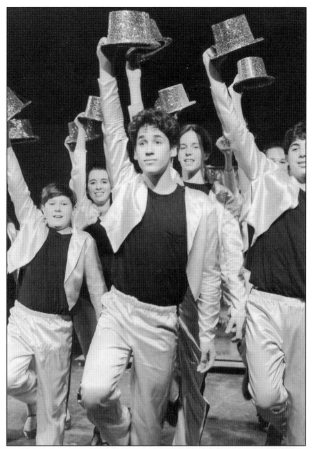

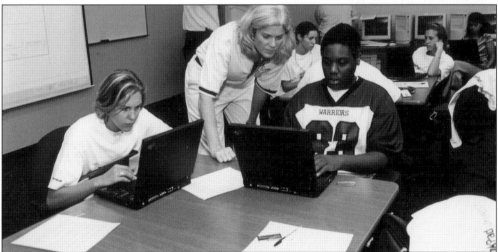

Many Centenary students now have the choice of taking some of their classes completely online. Students have wireless connectivity anywhere on the campus and can access the college course management system from wherever they have an Internet connection. The number of online offerings continues to grow as faculty and students become more comfortable with this new way of teaching and learning.

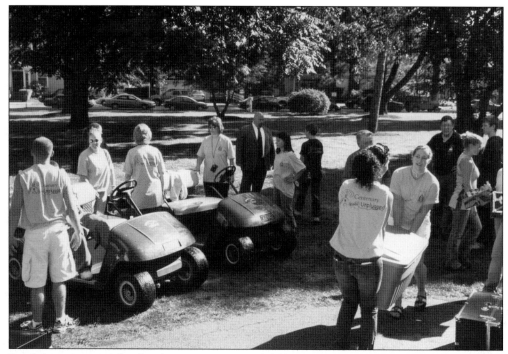

Freshman move-in day has become an annual fall event at Centenary, with faculty, staff, and upperclassmen pitching in to get new students settled into their dorms. A fleet of golf carts awaits parents' cars pulling up to the buildings to transport their son's or daughter's belongings quickly and efficiently to their rooms.

Helping students the minute they arrive on campus on their first day immediately builds a sense of caring and community. From the school's earliest days, this has been an important part of what makes Centenary College such a special place to be.

Beginning in 2006, Centenary students, faculty, and staff have given up their winter break and journeyed to New Orleans to help those whose lives were devastated by Hurricane Katrina. This involved training in basic carpentry and building demolition, a two-day, 1,200-mile bus trip, and sleeping at night on the floor of a church. The trips were organized by Prof. Norman Cetuk, who spent countless hours recruiting students, purchasing tools and safety equipment, and coordinating with church groups in Louisiana. Dr. Cetuk has won a national service award for his work on the Katrina Relief Project. Students who participated will never forget their experience. Cetuk (center) is seen here at a church in Metairie, Louisiana, that housed Centenary students in 2007.

On a misty January morning in 2006, students prepare to depart on the final leg of their New Orleans journey. After a 14-hour bus ride from New Jersey, they spent the previous night sleeping on the floor of a church gymnasium in Knoxville, Tennessee.

When students arrived in New Orleans, they were given their work assignments and instructions in basic safety procedures. Working in small teams, they would put in long hours amid debris, mud, and mold, with incredible destruction all around them.

No one who went to New Orleans was prepared for the magnitude of the catastrophe they would experience. For many families who had lost everything, the students were a source of great comfort, courage, and hope.

Centenary's chef, Linda Gonia, takes a well-deserved snooze after another long day preparing breakfast, lunch, and dinner for the hungry workers.

In 1999, Centenary opened the Center for Adult and Professional Studies (CAPS), with an off-campus learning center located in Parsippany, New Jersey. The center offers accelerated degree programs for working adults with professional schedules that prevent them from attending a more traditional undergraduate college. Now called the School of Professional Studies, it offers degree programs in Hackettstown, Parsippany, and Edison and at corporate sites throughout New Jersey.

In the fall of 1995, Centenary offered its first graduate degree program, in instructional leadership. Since then, it has added eight more master's programs, including a master of business administration, and graduate degrees in counseling, counseling psychology, and educational leadership.

After President Hoyt announced his departure, effective on December 31, 2008, Dr. Barbara-Jayne Lewthwaite, vice president for academic affairs and a Centenary faculty member for over 20 years, was named acting president on January 1, 2009. She was named the 12th president of Centenary College on May 15, 2009. Dr. Lewthwaite is only the second woman to assume the presidency and the second former Centenary faculty member to do so since Charles Wesley McCormick in 1900. As with all of the Centenary presidents who preceded her, President Lewthwaite faces a rapidly evolving educational landscape. As it has done so many times before in its long history, Centenary has conquered adversity and adapted to change. Its great strength has always been the outstanding faculty, staff, and administration, who are all dedicated to the phrase so proudly displayed on the college's official seal: *eruditio vera*—"true learning." After 145 years, Centenary remains—as President Lewthwaite puts it so well—"a beacon for the region."

THE PRESIDENTS OF CENTENARY COLLEGE

Dr. George H. Whitney: 1869–1895
Dr. Wilbert P. Ferguson: 1895–1900
Dr. Charles Wesley McCormick: 1900–1902
Dr. Eugene Allen Noble: 1902–1908
Dr. Jonathan Magie Meeker: 1908–1917
Dr. Robert Johns Trevorrow: 1917–1943
Dr. Hurst Robins Anderson: 1943–1948
Dr. Edward W. Seay: 1948–1976
Dr. Charles H. Dick: 1976–1985
Dr. Stephanie Bennett-Smith: 1985–2001
Dr. Kenneth L. Hoyt: 2001–2008
Dr. Barbara-Jayne Lewthwaite 2009–

BIBLIOGRAPHY

Custard, Leila Roberta. *Through Golden Years, 1867–1943*. New York: Lewis Historical Publishing Company, 1947.

Dalton, Ernest R. (1982). *A History of Centenary College*. Unpublished manuscript, Centenary College Archives.

Hammond, Albert O. (1917). *History of the Centenary Collegiate Institute*. Unpublished manuscript, Centenary College Archives.

Sullivan, Denis. *In Defence of Her Honor: The Tillie Smith Murder Case*. Flemington, NJ: D.H. Moreau Books, 2000.

DISCOVER THOUSANDS OF LOCAL HISTORY BOOKS FEATURING MILLIONS OF VINTAGE IMAGES

Arcadia Publishing, the leading local history publisher in the United States, is committed to making history accessible and meaningful through publishing books that celebrate and preserve the heritage of America's people and places.

Find more books like this at
www.arcadiapublishing.com

Search for your hometown history, your old stomping grounds, and even your favorite sports team.